TO THE MOST STYLISH MAN I KNOW

THE PARISIAN FIELD GUIDE
TO MEN'S STYLE

PRODUCTION

Ines de la Fressange and **Sophie Gachet**
Creative Team

Benoît Peverelli
Photographer

Rodolphe Bricard
Photography Assistant

Laura de Lucia
Digital Operator

Jeanne Le Bault
Stylist

Marielle Loubet
Grooming

Johanna Scher // Workingirl
Production

Jean-Louis Bergamini
Production Manager

Alexandre Touraine
Production Assistant

Armelle Saint-Mleux
Olga Sekulic
Good Fairies

FLAMMARION

French Edition

Julie Rouart
Editorial Director

Delphine Montagne
Editorial Administration Manager

Mélanie Puchault
Editor, assisted by **Manon Clercelet**
and **Marine Cousture**

English Edition

Kate Mascaro
Editorial Director

Helen Adedotun
Editor

Philippa Hurd
Translation from the French

Lindsay Porter
Copyediting

David Ewing
Proofreading

Pierre-Yann Lallaizon
Graphic Design and Typesetting

Corinne Trovarelli and **Margot Jourdan**
Production

Quat'coul
Color Separation

Printed in **Slovakia** by **TBB**

All photographs (except the portraits by Benoît Peverelli) are copyright
© the stores, restaurants, and brands, with the exception of the following:

Cartier: © Cartier / Eric Sauvage p. 152
Ami: © Yann Deret p. 159
The Broken Arm: © François Coquerel p. 162
Maison Kitsuné: © Elodie Daguin p. 167
Uniqlo: © Hufton + Crow p. 182
Maison Corthay: © Matthieu Dandoy p. 187
Photo of Cary Grant: © Keystone/ Hulton Archive/ Getty Images p. 193
Francis Kurkdjian: © Pascal Therme p. 200
Spa by Clarins Molitor: © Sébastien Giraud p. 202
La Barbière de Paris: © Hôtel de Crillon: A Rosewood Hotel p. 203
Clover Grill: © Nicolas Lobbestael p. 207
Le Drugstore: © Yann Deret p. 208
L'Ami Jean: © &SENS p. 217
Le Plomb du Cantal: © Sophie Gachet p. 219
Le Crôm-Exquis: © Philippe Martineau p. 224
Hôtel Ritz: bedroom: © Vincent Lerou; garden:
© Sophie Gachet p. 229
Hôtel Providence: © Benoit Linero p. 232
9 Hôtel Montparnasse: © David Grimbert p. 234

THE PARISIAN

FIELD GUIDE TO MEN'S STYLE

INES DE LA FRESSANGE
AND
SOPHIE GACHET

PHOTOGRAPHS
BENOÎT PEVERELLI

Flammarion

le parisien / lə paʁizjɛ̃ /, *n. masc.* **1.** the famous French ham-and-butter baguette sandwich. **2.** a male resident of Paris.

For me, when asked to define the *parisien*, it's definitely number one. But if we're talking about the Parisian male, well, that's a lot harder to describe.

What's his style? Cool? Classic? Sporty? All of the above. But that doesn't mean he doesn't follow certain ground rules. A real Parisian guy never wears short sleeved shirts or stonewashed jeans, for example.

So to help me really understand the concept, I asked my Parisian friends to come over with their own clothes for a style demo. They're all really inspiring, and they show off the best Parisian styles—whether in a navy suit or raw denim. To get their look, just follow their fashion tips and check out where they shop, how they get polished up, and what hangs in their closets. Then, if you prefer the famous *jambon-beurre* baguette, here's the best place to devour one in Paris: Le Petit Vendôme (8, rue des Capucines, 2e). With *le Parisien* in hand, you'll obviously look good!

CONTENTS

Of styles and men

COOL ARISTO

STAN, SALES MANAGER

The killer detail? Panache!

A blazer with ankle boots is stylish yet cool.

BEST STYLE TIPS

✓ Don't combine too many colors.

✓ Red pants aren't always a good idea.

✓ A blazer with silver buttons is always a bad idea.

✓ Wear long socks with a suit.

✓ Invest in good-quality shoes. They can really improve your look.

✓ Don't follow fashion—create your own style.

THE KILLER DETAIL

Unpolished shoes will ruin a good look.

I CAN'T LIVE WITHOUT

It's not very classy, but in the summer I can't live without my Havaianas flip-flops.

WORST FASHION FAUX PAS?

Sports socks worn with a suit.

STYLE ICON

Al Pacino in *The Godfather* is incredibly stylish.

MY STORES

HILDITCH & KEY
hilditchandkey.co.uk
International delivery available
> Their shirts are beautifully tailored and made of quality fabrics.

HOALEN OCEAN STORE
hoalen.com
International delivery available, excluding New Zealand
> For really soft, cotton T-shirts.

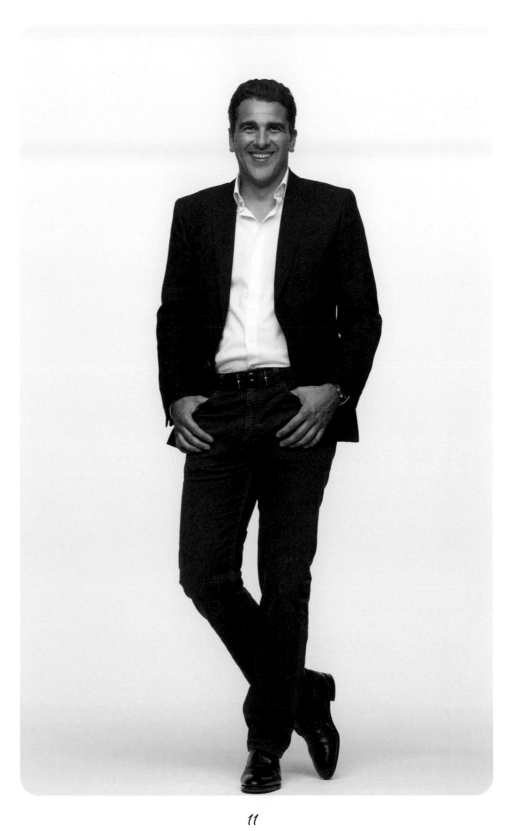

CASUALLY UNIQUE

CHRISTIAN, ACTOR

Shoes make the man!

I love ankle boots and any kind of high-tops.

PRACTICAL ADVICE

I ride a motorbike or a scooter, so my style tends to be **practical and casual**. You have to deal with whatever the weather throws at you.

STYLE STORIES

When I was young I went through a tacky phase, when I wore red tailcoats like a **circus ringmaster**.

I CAN'T LIVE WITHOUT

Uniqlo jeans— I'm a big fan.

I like wearing classic three-piece suits with a vest and tie.

STYLE ICON

I admire the style of **Steve McQueen**. He really knows how to carry off a turtleneck sweater and a gun.

I DON'T LEAVE HOME WITHOUT

A **vest**. I'll happily wear one either with a suit or with jeans.

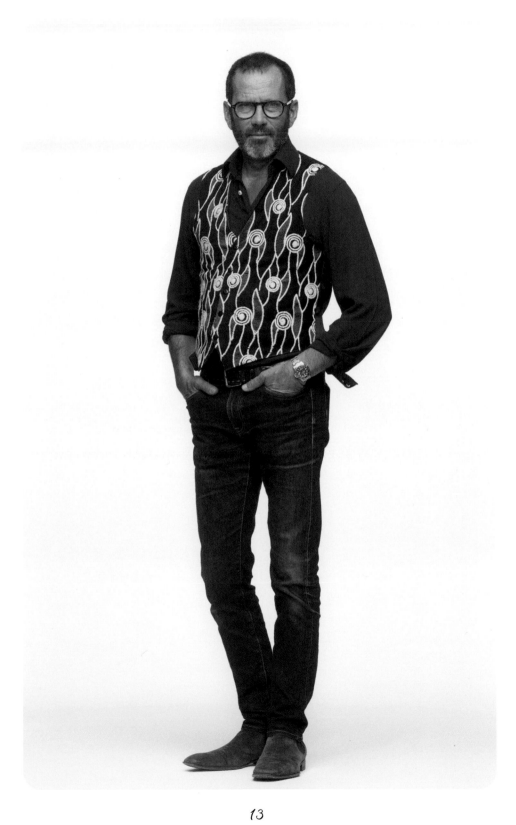

CHILLED-OUT DANDY

MANU, MUSICIAN

My mom worked as a seamstress for Dior, and she always told me to use caution when combining fabrics.

WORST FASHION FAUX PAS?

White **sports socks** worn with loafers.

THE KILLER DETAIL

Every detail is a killer detail.

I CAN'T LIVE WITHOUT

✓ Jeggings when I'm relaxing.

✓ A V-neck sweater for everyday wear.

rocks a great style.

MY STORES

MARCHAND DRAPIER
marchand-drapier.com

SAINT LAURENT
ysl.com
International delivery available

MAISON MARGIELA
maisonmargiela.com
International delivery available

LACOSTE
lacoste.com
International delivery available

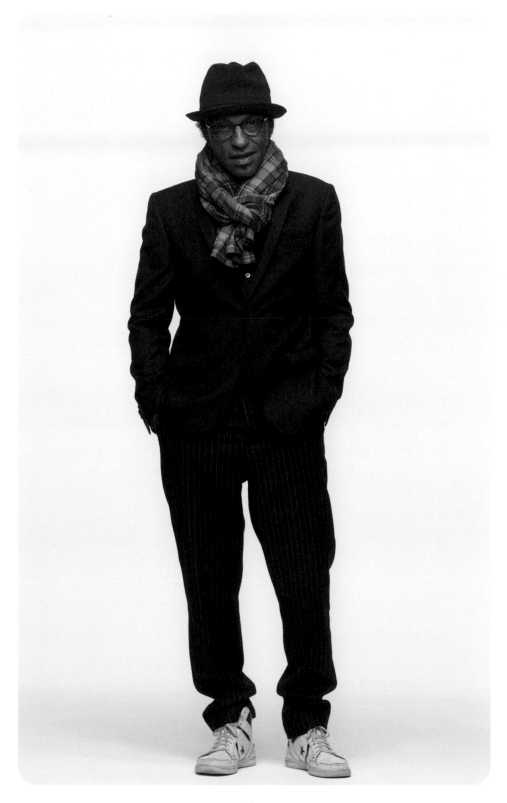

15

OLD-SCHOOL

VINCENT, DESIGNER

I always wear a jacket, even on vacation. The shorts and flip-flops look is not at all me. On the beach, I wear long sleeves and long pants!

My style signature is striped socks.

INES LIKES...

A stripe cocktail!

BEST STYLE TIP

My friend, the writer François Baudot, said: "When you've found your style and Paris loves you for it, don't change a thing." Recently I tried growing a beard. I got rid of it fast.

You wouldn't call my style relaxed. I like the tailored look.

WORST FASHION FAUX PAS?

Wearing **sweats** to a museum.

STYLE ICON

The writer **Thadée Klossowski.**

MY STORES

PARIS · EXCLUSIVE

GABRIEL PARIS
(formerly Eglé Bespoke)
26, rue du Mont-Thabor, Paris 1er
> This is where I buy all my suits.
I have a whole collection in seersucker.

THIERRY LASRY
thierrylasry.com
International delivery available
> For glasses.

DRIES VAN NOTEN
driesvannoten.com

SANTONI
santonishoes.com
International delivery available
> For shoes.

> It's a shame for us Parisians that there's no longer a Brooks Brothers store in Paris. Fortunately, there's still brooksbrothers.com.

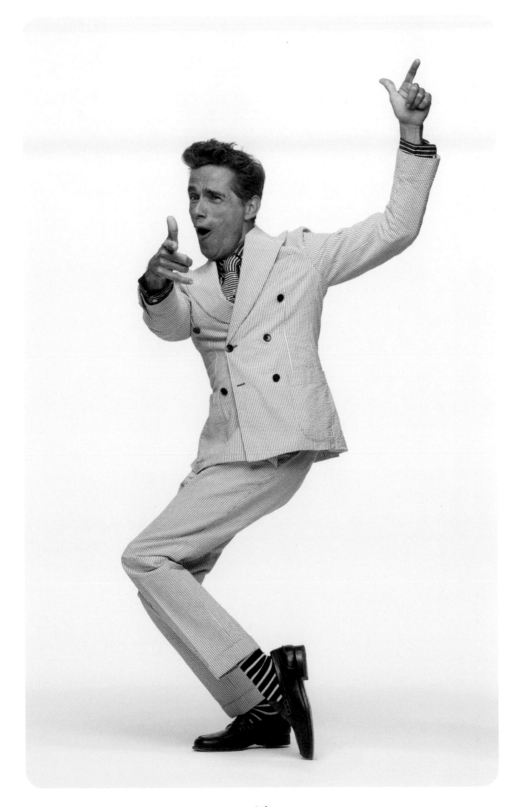

17

SIMPLY ELEGANT

GEORGES, RUSSIAN PRINCE

Choosing my socks every morning is a real challenge. I like Japanese brand Tabio (tabiousa.com or tabio.com/uk).

INES LIKES...

I love the Anglo-American feel of this combination of Savile Row check shirt + dark blazer and loafers (Ralph Lauren).

WORST FASHION FAUX PAS?

THE POCKET SQUARE.

I DON'T LEAVE HOME WITHOUT

Black jeans from Marks & Spencer (marksandspencer.com). If you're tall, the leg length is perfect.

My goal? To be elegant without thinking too hard about it.

STYLE ICON

Whether he's wearing a suit or a T-shirt, **Barack Obama** manages to be elegant and cool at the same time.

SMART THINKING

I want to feel comfortable in my clothes, and I adapt them to fit the circumstances.

THE KILLER DETAIL

A tie. But you have to be careful: a tie that's too long, too wide, or too red can be fatal.

MY STORES

HERMÈS
hermes.com
International delivery available

MARKS & SPENCER
marksandspencer.com

RALPH LAUREN
ralphlauren.com
International delivery available

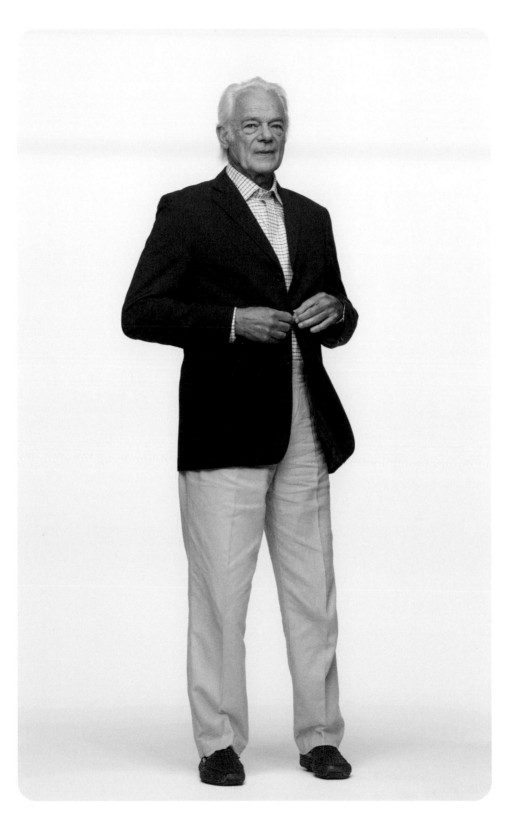

19

SIMPLY CASUAL

RODOLPHE, PHOTOGRAPHER

Donald Trump. Orange hair and skin + red tie + shapeless suit = bad style.

INES LIKES…

A "work wear" jacket adds a lot of style to the jeans and T-shirt look. An army surplus jacket would have the same effect.

STYLE ICON

Writer Thadée Klossowski **is the incarnation of masculine elegance.**

EVERY YEAR I BUY THE SAME JEANS AT A.P.C. AND I ALWAYS WEAR THE SAME NAVY, CREW NECK SWEATER.

THE KILLER DETAIL

Lace-up shoes. I always wear the same ones by Manfield (manfield.fr). Never sneakers!

MY MUST-HAVE

My **work jacket**. I wore it when I worked in a factory in Saint-Nazaire, and have been wearing it ever since. It's all beat-up now from years of riding on my motor scooter.

The boxer shorts at Monoprix (monoprix.fr) are great.

MY STORES

UNIQLO
uniqlo.com
International delivery available
> I'm always sure to find something.

A.P.C.
usonline.apc.fr in the US or apc.fr/wwuk
International delivery available
> For jeans.

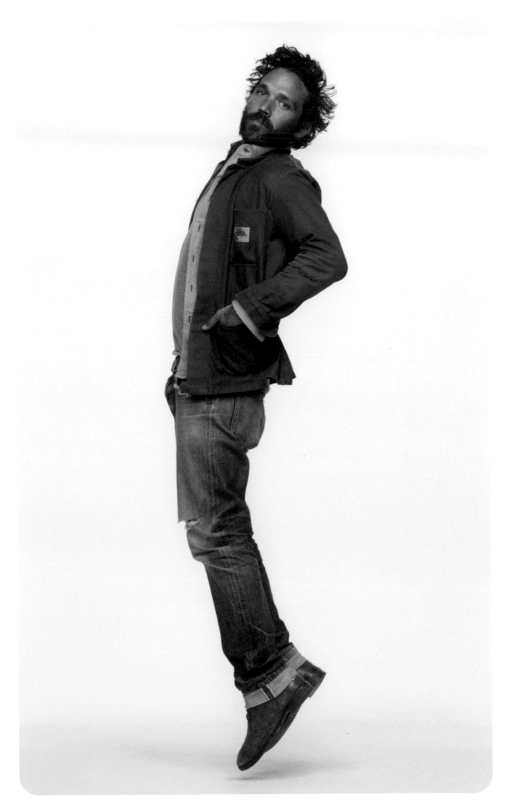

STREAMLINED
(AND SOMETIMES UNDERGROUND)

HENRI, ARTIST

PRACTICAL ADVICE

Colette used to be next door to my apartment, so I didn't have far to go for shopping. Now I'll go to **Saint Laurent** (213, rue Saint-Honoré, Paris 1er).

INES LIKES...

White jeans look good even in winter. Particularly with a black sweater and a vintage black-and-white overcoat.

FOR THIS PHOTO I KEPT MY LOOK UNDER CONTROL, **BUT SOMETIMES I CAN BE MUCH MORE** UNDERGROUND.

My girlfriend is always telling me not to mix colors too much. But I'm not sure I always listen.

THE KILLER DETAIL

Bracelets. They add a touch of individuality.

There's nothing I couldn't live without. **Except my boxers.**

WORST FASHION FAUX PAS?

Pool sliders with **socks**.

STYLE ICON

Rapper **Famous Dex** is stylish and always sports the latest T-shirts.

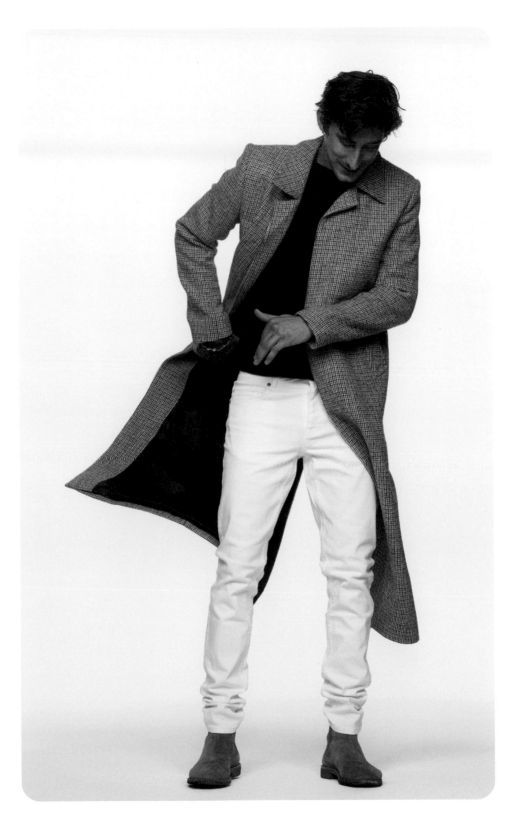

SEVENTIES CHIC

NASSIM, ACTOR

My look can be summed up as a jacket and flares.

INES LIKES…

It's not just girls who love shopping in vintage stores. And a pair of flares can really make an impact!

THE KILLER DETAIL

The way you manage to **combine fabrics**, sizes, past and present fashions to create your own style.

I CAN'T LIVE WITHOUT

Wide **black velvet** pants.

PRACTICAL ADVICE

I never dress to suit the weather, but always to suit my mood. I can wear a cashmere sweater in ninety-degree heat, and go bare-chested under a jacket in January. I regret it every time, but that doesn't stop me from doing it.

I TAKE INSPIRATION FROM THE DISCO YEARS. *I ONLY BUY VINTAGE.*

STYLE ICON

If I had to choose one, it would be a mixture of David Bowie, Mick Jagger, and Yves Saint Laurent in the 1970s.

MY STORES

KILOSHOP
kilo-shop.com
> In these stores they sell vintage clothes by weight.

GUERRISOL
guerrisol.fr

THE CLIGNANCOURT FLEA MARKET
Paris, 18ᵉ
marcheauxpuces-saintouen.com

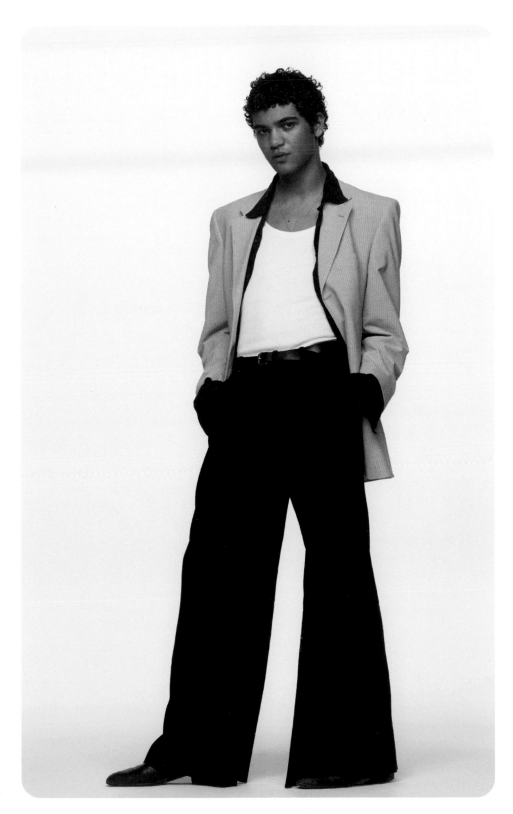

COOL & ELEGANT

MIKE, FOUNDER OF AN EVENTS MANAGEMENT AGENCY

MY FASHION
FETISH

Navy blue. It's stylish but never dull.

- - - - - - - - - - -

WORST FASHION
FAUX PAS?

Wearing white socks when you're not playing sports.

INES LIKES...

The classic shirt and vest are offset by the cool blouson jacket and denims.

My wife always told me not to wear more than three colors. I listen to my wife.

- - - - - - - - - - -

THE KILLER DETAIL

A watch. Mine is a vintage Rolex that I was given on my thirty-fifth birthday.

I DON'T LEAVE HOME WITHOUT

My hoodie by Frescobol Carioca and my swimwear by Gili's (frescobolcarioca.com and gilis.com; international delivery available).

STYLE ICON

James Bond is a style icon. Sean Connery and Timothy Dalton played the role very well.

MY STORES

BRUNELLO CUCINELLI
shop.brunellocucinelli.com
International delivery available
> For overcoats and cashmere sweaters.

AMI
amiparis.com
International delivery available

UNIQLO
uniqlo.com
International delivery available

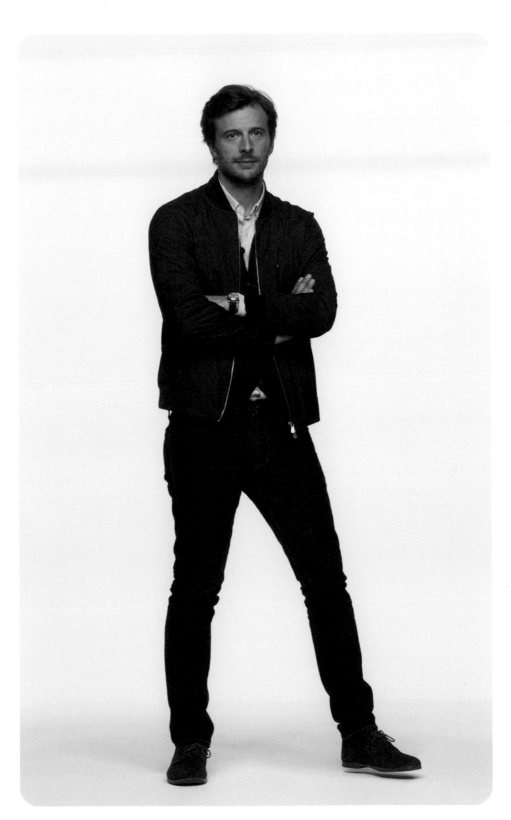

21

CASUAL CHIC

AYMERIC, COFOUNDER OF A CLOTHING BRAND

BEST STYLE TIP

Don't ever wear beige pants + light blue shirt with a sweater slung over your shoulders.

INES LIKES…

A beige raincoat over raw denim jeans and a gray sweater is simply chic.

STYLE ICON

James Dean and his white T-shirt are legendary.

WORST FASHION FAUX PAS?

Apart from white socks (an international fashion faux pas), make sure that your clothes are neither too tight nor too loose. **Basically, buy clothes that fit!**

MY STYLE MANTRA

Never too classic, never too trendy.

THE KILLER DETAIL

The cut of a piece of clothing.

I CAN'T LIVE WITHOUT

For me a **watch** and a **belt** are essential. I adore the Breguet watch my wife gave me.

MY STORES

A.P.C.
usonline.apc.fr in the US or apc.fr/wwuk
International delivery available

GILI'S
gilis.com
International delivery available
> My brand for swimwear, T-shirts, and espadrilles. The multicolor prints put you in a good mood.

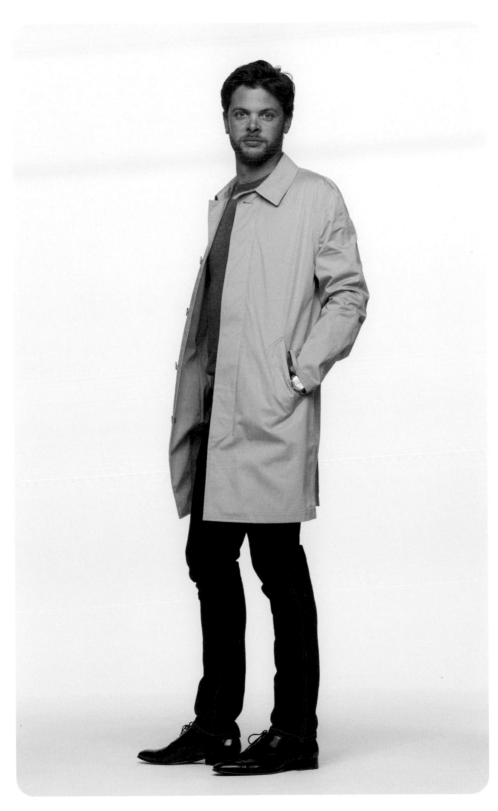

29

DARK & BROODING

GENJI, MUSICIAN

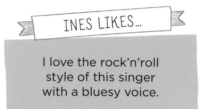

INES LIKES...

I love the rock'n'roll style of this singer with a bluesy voice.

My tattoos are inspired by Native American culture—my roots. They're also a kind of clothing.

I DON'T LEAVE HOME WITHOUT

A black T-shirt, a leather jacket, and boots.

Whatever happens, I wear **boots**.
I own a pair of **Redskins** (redskins.fr).

MY STORE

PAUL SMITH
paulsmith.com
International delivery available

STYLE ICON

I love the sleek, pared-down style of singer **Nick Cave**.

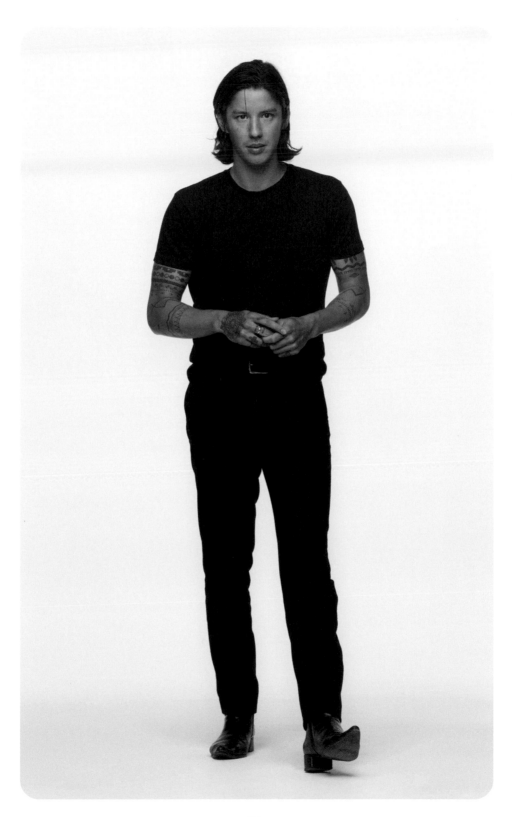

SIMPLY CHIC

DENIS, MANAGING DIRECTOR OF A MAJOR COMPANY

MY FASHION

FETISH

Monday through Friday
I wear exactly **the same look.**

INES LIKES…

A white shirt with
a navy blue blazer
and raw denim jeans
is the Parisian's uniform.

HOW DO I DEFINE MY STYLE? PORNO CHIC!
JUST KIDDING: ULTRA MACHO.

WORST FASHION
FAUX PAS?

White socks. Or **ankle
socks**. Or a **short-sleeve
shirt**. Or, even worse,
wearing **shorts** in the city.

MY MUST-HAVE

A **white shirt**.

THE KILLER DETAIL

A good hat from **Motsch**
when the weather's gray.

STYLE ICON

Lino Ventura is a perfect example
of style and class.

MY STORE

DIOR
dior.com
International delivery available
> J'adore!

*Wearing XL clothes
won't make you
look thinner!*

32

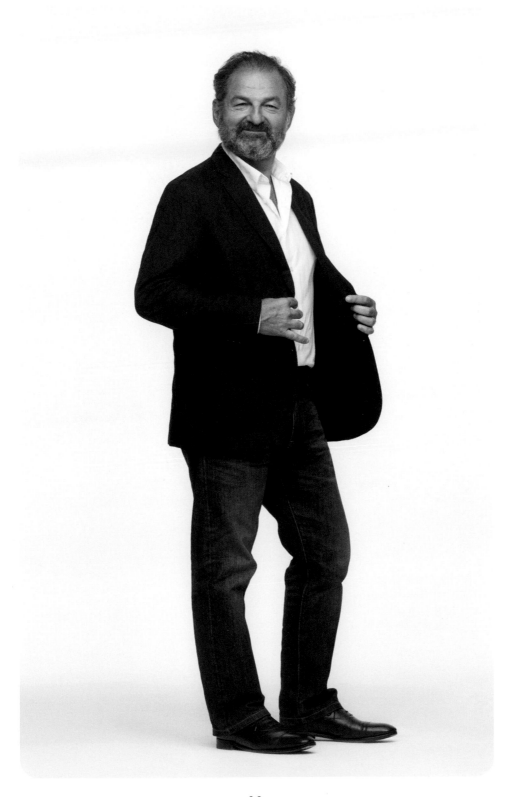

ULTRA SIMPLE

BERNARD, THEATER DIRECTOR, PRODUCER, AND MANAGER

How would I define my style? Modest, I hope!

This go-everywhere look means you can proceed from the office to a dinner with friends without going home.

BEST STYLE TIPS

Be **classy** at all costs, and avoid **vulgarity**.

THE KILLER DETAIL

Look **happy**!

WORST FASHION FAUX PAS?

Colored socks or ankle socks. I can remember one French president who wore green ankle socks.

MY MUST-HAVE

My **Berluti** shoes.

I LIKE TRYING OUT NEW STORES WHEN I GO SHOPPING. I DON'T SPEND MORE THAN FIVE MINUTES AND IT HAS TO SUIT ME IMMEDIATELY.

STYLE ICON

Yves Saint Laurent. We were both born in Oran in Algeria. He was my sister's childhood friend, and both of them left for Paris at the same time.

MY STORES

ARTHUR & FOX
19, rue Clément-Marot, Paris 8ᵉ
> Because it's right next door to my theater.

PARIS EXCLUSIVE

JLR
jlrparis.com
EU delivery available
> For bespoke shirts.

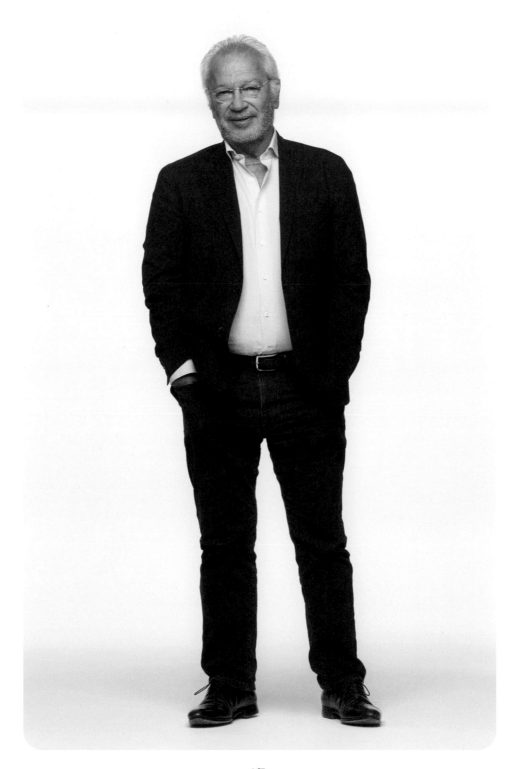

CLASSIC STYLE

BERNARD, WRITER

MY CURRENT LOOK

✓ Almond-green whipcord suit (tailor: the late Daniel Mare).

✓ White shirt with Italian collar and double cuffs (Hilditch & Key).

✓ Gold and mother-of-pearl button-shaped cufflinks (vintage, from my father).

✓ Silk tie (vintage Hermès, 1977).

✓ Patterned English suspenders (vintage Pape, 1989).

✓ Green, lisle, knee-length socks (Charles Lancar's stall at the market on avenue du Président-Wilson, Paris, 16ᵉ, on the right halfway along as you walk up the market).

✓ Suede boots (vintage Tod's, 1998).

✓ Walking stick (Hyaku-yen—literally the discount "100 yen shop"—Tokyo).

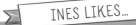

INES LIKES...

Formerly a director of *Vogue Hommes*, this writer has a natural elegance.

If you ask me to define my style, I'd say "Uncle Bernie."

STYLE ICON

Paul Guilbert was tall, with a mop of red hair, green eyes, an aquiline nose, and a cheeky, sensual mouth, and he usually wore an almond green suit. My friends and I (who were twenty at that time) admired and loved this "old man" (who was just over forty). He had been literary secretary to Joseph Kessel, and was an important journalist on the *Quotidien de Paris*, and at *Nouvelles Littéraires*. He was fun and spoke French with a beautifully rich, sonorous voice.

WORST FASHION FAUX PAS?

Yellow socks with a **blue suit**. And wearing a wristwatch with a tuxedo.

MY STORES

PAPE
4, avenue Rapp, Paris 7ᵉ
> For bespoke suits.

PARIS EXCLUSIVE

MONOPRIX
monoprix.fr

TURNBULL & ASSER
turnbullandasser.co.uk
International delivery available
> **An English tailor by appointment to Prince Charles.**

HILDITCH & KEY
hilditchandkey.co.uk
International delivery available

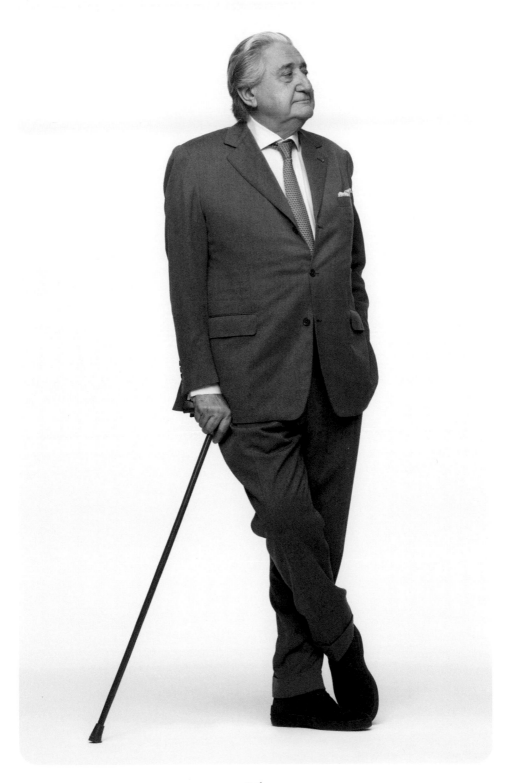

SMART CHIC

NATHAN, FRENCH IVY LEAGUE GRADUATE
AND FUTURE PRESIDENT OF FRANCE

BEST STYLE TIP

Develop a **distaste for others' tastes**. For example, my mother told me that a white suit is a fashion faux pas. She's right, but I don't care.

I don't really have a style. It's thrown together from whatever I like. As I buy everything vintage, I'm limited by what I can find.

I DON'T LEAVE HOME WITHOUT

A moth-eaten **Sulka dressing gown**. It's the item of clothing I'll never part with.

STYLE ICON

Luigi d'Urso, father of Nine and Violette, Ines's daughters. He was the master of largesse, with wide lapels and ample suits. He had his father's suits altered to fit his own size.

INES LIKES...

The slightly vintage feel of a well-tailored suit (Anderson & Sheppard) worn with a denim shirt by Gap is a really cool combination.

WORST FASHION FAUX PAS?

Men who wear tuxedo jackets with jeans during the day. Worse, short socks with a suit. The glimpse of a chubby, hairy calf is unacceptable.

THE KILLER DETAIL

Well-draped **pants** that break perfectly over the top of the shoe.

MY STORES

SAVVY ROW
savvyrow.co.uk
International delivery available
> The online store for all things vintage and British.

CHEZ AMMAR, THE VINTAGE STORE
65, rue Nollet, Paris 17e

JOHN LOBB
johnlobb.com
International delivery available

PARIS EXCLUSIVE

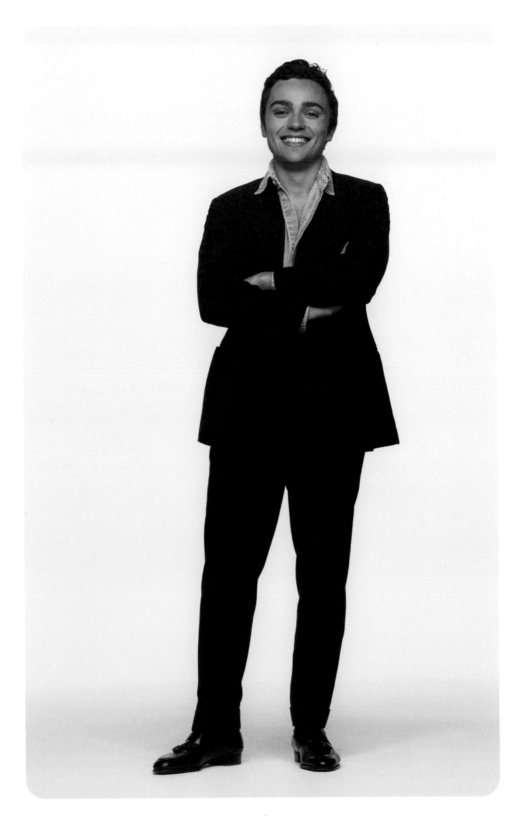

CUTTING-EDGE COOL

THOMAS, ARCHITECT

My style remains the same, but I change my shoes every day. I've got a huge collection of sneakers.

Chinos (Uniqlo) plus sweatshirt (A.P.C.) worn with sneakers is always a cool look.

BEST STYLE TIP

IT COMES FROM MY WIFE WHO'S A DESIGNER AND WHO ALWAYS SAYS: *LESS IS MORE.*

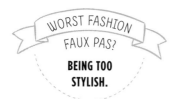

WORST FASHION FAUX PAS?

BEING TOO STYLISH.

THE KILLER DETAIL

A good pair of shoes. I'm a fan of **Stan Smith Originals**—they're sleeker and the tongue is totally flat. They're not easy to find, but you can still track some down.

STYLE ICON

Bill Gates.

MY STORES

NIKE
nike.com
International delivery available
> For sportswear.

A.P.C.
usonline.apc.fr in the US or apc.fr/wwuk
International delivery available
> For citywear.

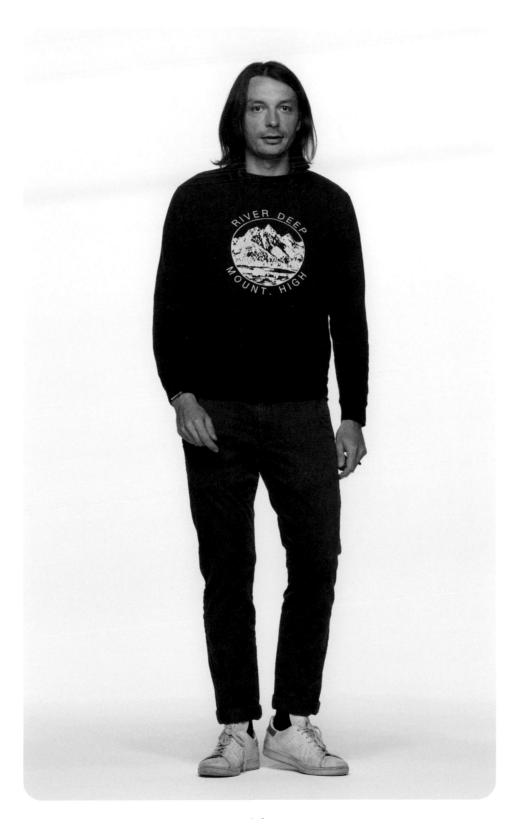

41

SIMPLE & RUGGED

ABDOULAYE, THAI BOXING WORLD CHAMPION
AND OWNER OF A SPORTS CLUB

A smile.

A suit (Ermenegildo Zegna) combined with stylish sneakers (Lanvin) really packs a punch.

WORST FASHION FAUX PAS?

Pool sliders with socks. Or mixing clothes of almost the same color, such as dark brown with light brown.

STYLE ICON

I love the panache of actors **Denzel Washington** and **Omari Hardwick**.

I COULDN'T LIVE WITHOUT MY SNEAKERS.

I'm a big fan of leather goods. An essential item is a wallet for my phone and keys.
I also have a large black leather sports bag, which I had made for me.

BEST STYLE TIP

My mother always told me: "Don't wear striped pants with a striped shirt."

MY STORES

LANVIN
lanvin.com
International delivery available

ERMENEGILDO ZEGNA
zegna.com
International delivery available
> Because they sell pants tailored to fit men who don't have skinny thighs.

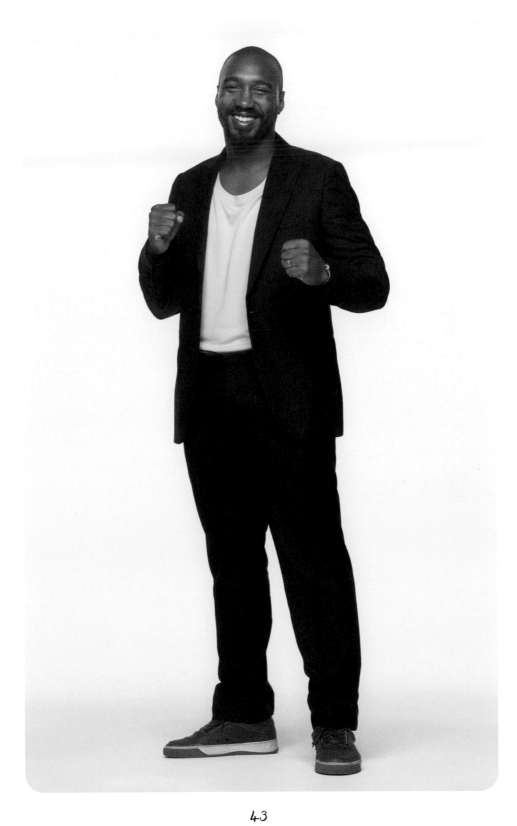

FASHION MIX

MARIN, MULTIDISCIPLINARY ARTIST

I mix vintage with modern.
I try to be creative.

BEST STYLE TIP

Wear **navy blue**.
It's always stylish.

THE KILLER DETAIL

Boots with a patina. I don't like shoes that look brand-new. I spend weeks taking the shine off my shoes. Sometimes I lend them to a friend who breaks them in for me for three months.

STYLE STORIES

I've been known to buy vintage jeans and have them re-fitted to my size.

MY MUST-HAVE

A work jacket and a bandana.

MY FASHION FETISH

Layering.

MY STORE

SAVE KHAKI
savekhaki.com
International delivery available

I often buy second-hand in vintage stores, as I know that means I won't see my clothes worn by anyone else. I also like clothes to look lived-in.

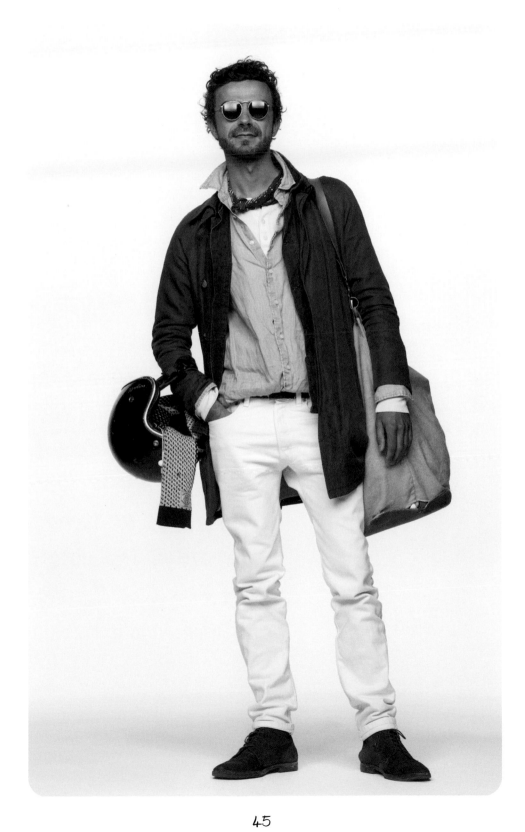

45

CASUALLY FRENCH

JÉRÔME, FASHION DESIGNER

I know it's unusual, but **I buy clothes designed by my wife** (Isabel Marant). For example, the pants I'm wearing in this photo are from her collection.

I love any piece that has had a life, like this old sweatshirt (in the photo) that I picked up second-hand in Los Angeles. We've been through a lot together.

WORST FASHION FAUX PAS?

Stockpiling too many good pieces and not knowing how to combine them.

THE KILLER DETAIL

BEING YOURSELF.

MY STORES

ROSE BOWL FLEA MARKET
Pasadena, California
rosebowlstadium.com/events/flea-market

ISABEL MARANT
isabelmarant.com
International delivery available
> My wife's store.

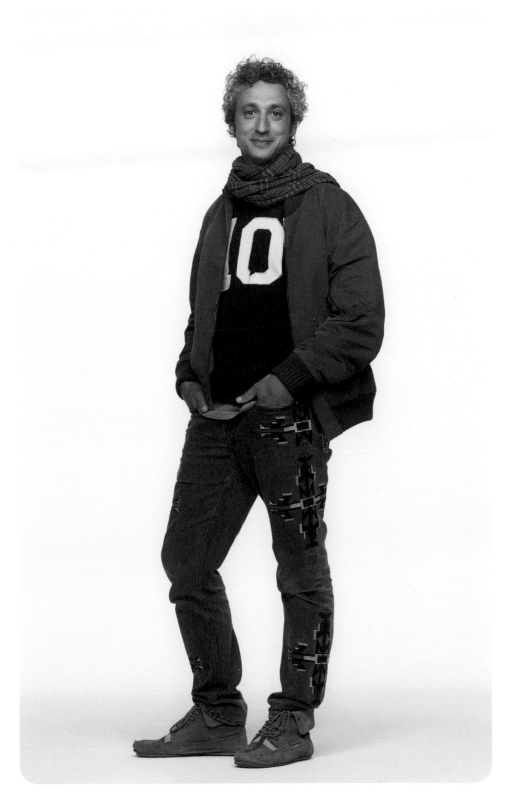

41

RELAXED CHIC

JEAN-JACQUES, FASHION AND LUXURY GOODS CONSULTANT

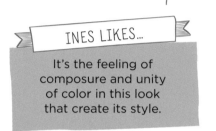

INES LIKES...

It's the feeling of composure and unity of color in this look that create its style.

My style isn't complicated, it's a uniform. Like a soldier or a priest. Your personality comes out when you justify the look. I'm paid to listen to other people. To enhance the dialogue, you need neutrality. My look can't hamper the conversation. I can get ready in five minutes: a suit by Dior Homme or John Smedley, shoes by Church's, and my Rolex watch (all deliver online orders internationally). On the weekends, I wear Uniqlo or Lacoste.

THE KILLER DETAIL

My **bespoke Lafont glasses**. I had these frames copied— I saw architect Ieoh Ming Pei wearing similar ones.

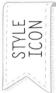

STYLE ICON

John F. Kennedy had a classic, cool attitude. When he disembarked from Air Force One he did it with elegance.

MY STORE

LE BON MARCHÉ
24sevres.com
International delivery available
> I adore shopping here. It has the perfect balance of young designers and tried-and-tested brands.

WORST FASHION FAUX PAS?

To be bursting out of your clothes.

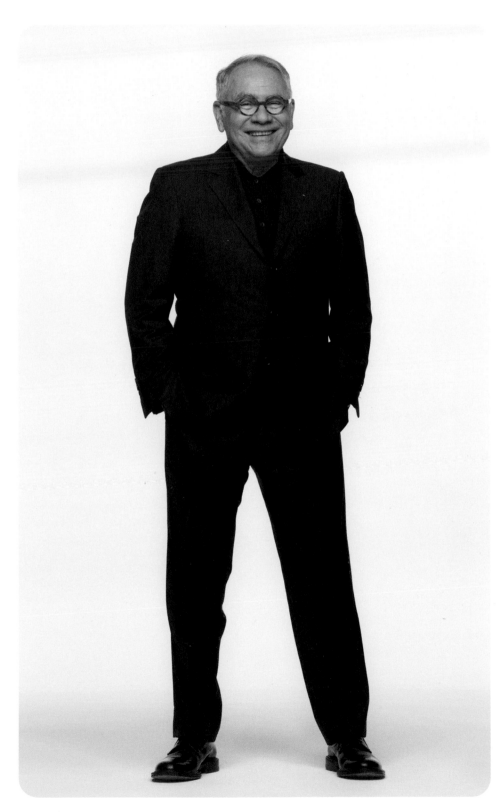

49

LOW PROFILE

LOÏC, DOCUMENTARY DIRECTOR

WORST FASHION FAUX PAS?

Wearing jeans that look like you've spilled bleach all over them. **Denim overload** is also to be avoided.

I don't know how to define my style. I'd say unconscious psychopath. In any case, I don't dress to stand out from the crowd.

BEST STYLE TIP

It's a piece of advice I was given by make-up artist Topolino: use a good **moisturizer**.

INES LIKES...

Shirt, jeans, sneakers—but it's the beige jacket that adds the cutting-edge touch. And the book in the pocket adds a highbrow (and fashionable) detail.

THE KILLER DETAIL

Jeans that create **a nice butt**. Having a great derriere is not just for girls!

MY FASHION FETISH

Plaid shirts. I'm wearing them less, as my friends started a petition to get me to stop. So I gave them all to my brother. Otherwise, a white T-shirt. I can spend hours looking for a well-cut, white T-shirt. Designers love designing bad, white T-shirts. Poorly cut, or with logos on the front: I hate all that. I've found good ones in the US, at James Perse, Old Navy, or J. Crew.

MY STORES

AMI
amiparis.com
International delivery available

A.P.C.
usonline.apc.fr in the US
or apc.fr/wwuk
International delivery available

MAISON KITSUNÉ
shop.kitsune.fr
International delivery available

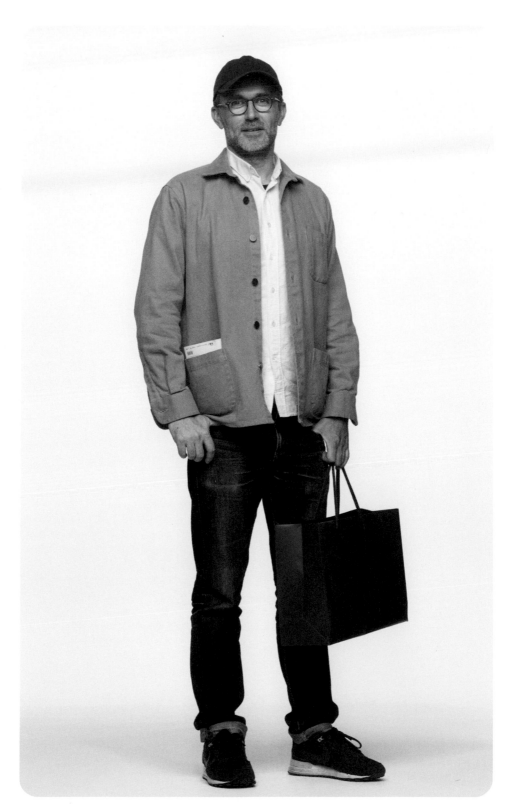

SLIPPER JUNKIE

TRISTAN, SOCIAL MEDIA DIRECTOR

I'M A PARISIAN GUY WHO'S NEITHER HIP NOR "BOBO" (BOURGEOIS-BOHEMIAN).

WORST FASHION FAUX PAS?

Wearing **a tie with jeans**.

I CAN'T LIVE WITHOUT

My vintage **leather jacket**, which I bought in New York ten years ago.

STYLE ICON

Marshal Murat, Napoleon's brother-in-law and sometime King of Naples. For the cavalry officer uniform he wore in Napoleon's army; his ceremonial gear adorned with military decorations; and, above all, for his green jacket with a leopard skin casually tossed over his shoulders. It reminds me of interior designer Madeleine Castaing's style.

BEST STYLE TIP

I'm inspired by **Jamie Hince** of **The Kills**, when he was on stage, playing guitar, and wearing a trailing leopard-print scarf, which he had purloined from his then-fiancée, Kate Moss.

I wear slippers all the time. Even in winter, even with a suit.

MY STORES

STUBBS & WOOTTON
stubbsandwootton.com
International delivery available
> **For slippers.**

MAISON COURTOT
maison-courtot.com
> **For bespoke shirts.**

CAUSSE GANTIER
causse-gantier.fr/en
International delivery available
> **For driving gloves.**

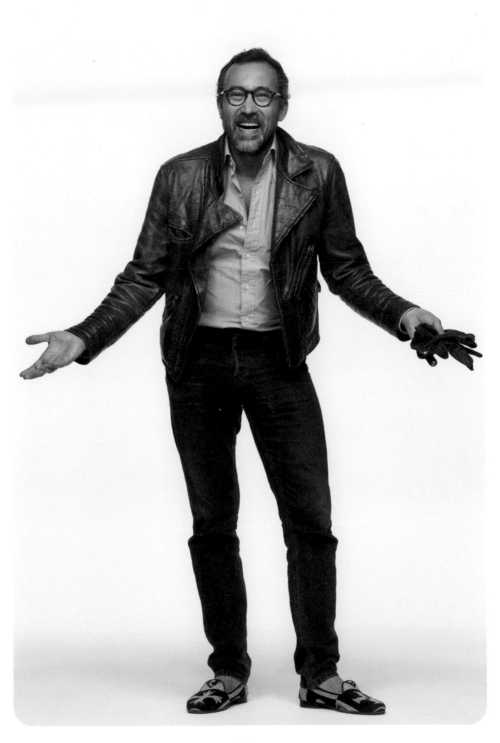

SPORTSWEAR

ÉRIC, CHAUFFEUR

INES LIKES…

The combination of sneakers, denim, and bomber jacket is always a cool cocktail.

I can't wear a suit. It makes me look like I'm getting married.

THE KILLER DETAIL

My New Balance sneakers.

STYLE ICON

Steve McQueen and his Mustang GT in *Bullitt*.

BEST STYLE TIP

Don't wear oversized T-shirts.

MY MUST-HAVE

Jeans, T-shirt, and sneakers— that's <u>my uniform</u>.

MY STORE

LEVI'S
levi.com
International delivery available
> For 511s.

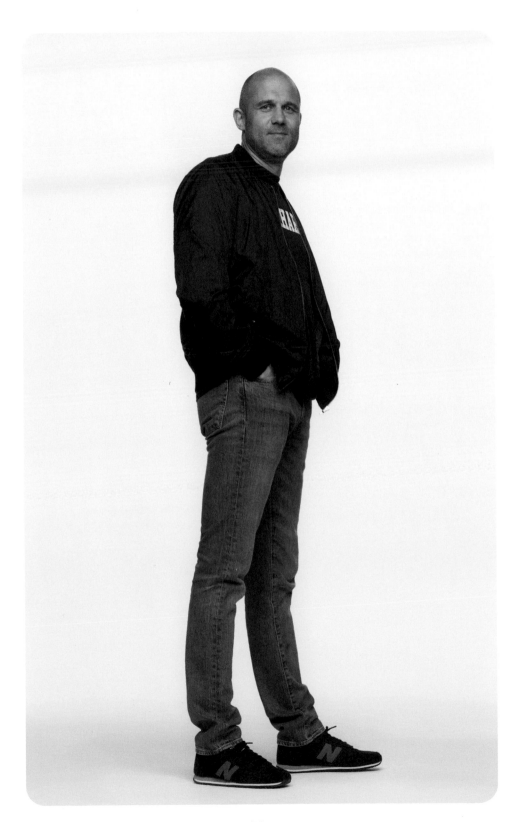

CREATIVE

THOMAS, CREATOR OF A CABINET OF CURIOSITIES

MY STYLE MANTRA

I only buy clothes from designers whose brands have remained a reasonable size. This can be young designers, but also **Giorgio Armani**, who has managed to remain independent and faithful to his original intentions, despite his success.

My style? Spontaneous. I'm wearing a bracelet (Le Gramme, legramme.com) which I gave to my wife and which she no longer wears. I love stealing things from her.

INES LIKES...

The originality of this jacket (Dries Van Noten) creates the entire look.

MY MUST-HAVES

Moccasin-style loafers by Visvim and my jacket by Japanese brand Bedwin & the Heartbreakers (bedwintokyo.com).

WORST FASHION FAUX PAS?

Having a **belt that doesn't match your shoes** when wearing a suit.

THE KILLER DETAIL

Kindness.

STYLE ICON

When I imagine a stylish man, I think of **Robert Redford** photographed by Ron Galella in 1974.

MY STORE

MAISON KITSUNÉ
shop.kitsune.fr
International delivery available
> I like brands that transmit cultural content, hold values, and are a world in themselves.

With an associate, I've created the brand GEYM (geym.eu), aimed at urban, active, sporty men who are always on the go. You can find it at Le Bon Marché in Paris.

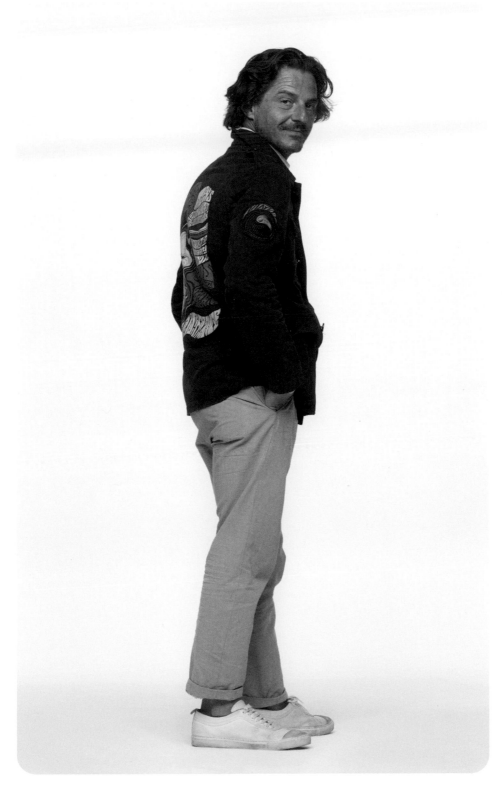

51

SPORTING STYLE

ARNAUD, SPORTS CONSULTANT

A **scarf** or an **indigo Tuareg tagelmust**—I've always got something around my neck.

INES LIKES...

The gray accent with a white T-shirt brightens the look.

I don't like wearing T-shirts that are too long, so my thing is to tuck just the front of the T-shirt into my pants.

WORST FASHION FAUX PAS?

A cellphone attached to a belt, or a short-sleeve button-down shirt.

Wearing navy blue is better than wearing black—it softens your look.

MY STORES

PAUL SMITH
paulsmith.com
International delivery available

LACOSTE
lacoste.com
International delivery available
> I love their Live! collection.

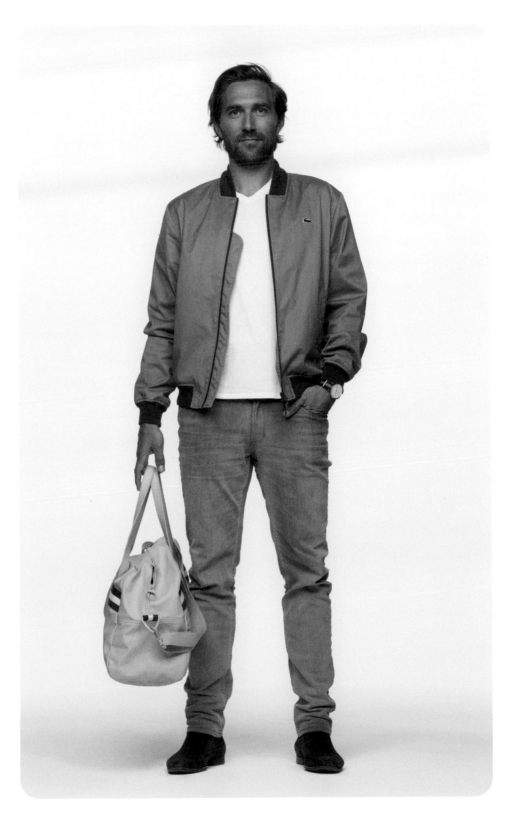

EASY CHIC

CHRISTIAN, COMPANY DIRECTOR

When it comes to style, I gravitate toward the essentials with a whole range of basics:
high-top shoes, jeans, sweater, jacket.

INES LIKES...

The cut of these clothes highlights his lean build.

MY MUST-HAVES

My Uniqlo jeans, high-top sneakers, and my wedding ring.

BEST STYLE TIP

Ask yourself, "Do I feel good in this?"

STYLE ICONS

I admire **Steve McQueen** for the twist he brings to basic pieces. And **James Dean** for his casual attitude combined with a carefully crafted style.

I'm always looking to offset pieces: if I'm wearing a T-shirt, I put on ankle boots, and if I'm in a shirt, I wear sneakers.

THE KILLER DETAIL

Colored **cashmere socks**.

WORST FASHION FAUX PAS?

A look that you're not comfortable in.

MY STORES

ACNE STUDIOS
acnestudios.com
International delivery available
> For knitwear.

UNIQLO
uniqlo.com
International delivery available
> For jeans.

DIOR
dior.com
International delivery available
> For suits.

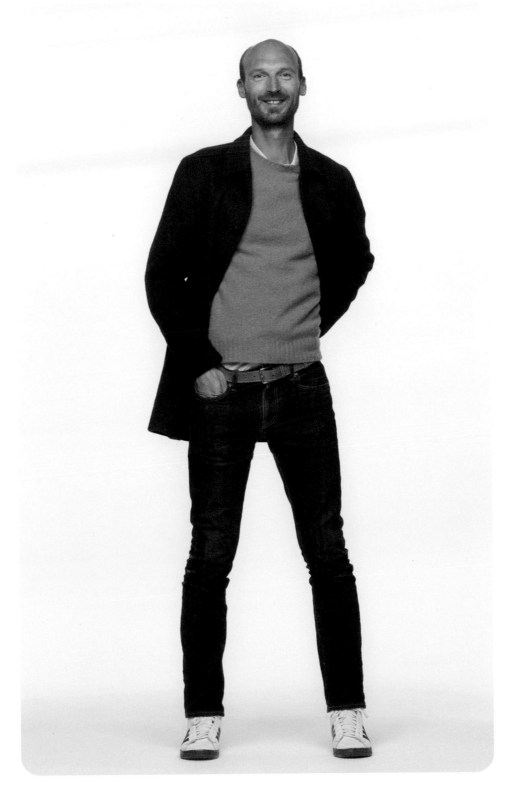

CLASSY VINTAGE

BERTRAND, MUSICIAN AND PRODUCER

*I'm not into fashion:
I just try to dress and
feel good without thinking
too hard about it.*

STYLE ICONS

In the music world, I love the panache of **Charlie Watts** and **Bryan Ferry.**

WORST FASHION FAUX PAS?

As in life, it's wearing stuff you don't like, thinking it'll work.

- - - - - - - - - -

With a nylon <u>windbreaker</u> and a <u>scarf</u>, I can go anywhere.

BEST STYLE TIP

When I was fourteen, I was out on a glacier with a guide who I really looked up to. I asked him why he **was combing his hair** when there was no one around. He replied that he was doing it for himself.

- - - - - - - - - -

My style is anachronistic, **but not retro enough to be up-to-date. I have a tendency to wear clothes that fit too snugly, and that makes me look fat.**

- - - - - - - - - -

MY STORE

> I don't really have a favorite store, and I'm not a regular client of the luxury fashion industry. However, I recommend Michaël Ohnona (ohnona.com), who creates perfect suits.

I avoid jackets with pockets over the belly. If you're not a skinny teenager, they make you look like you're wearing a life buoy.

CLASSIC CHIC

FRANÇOIS, PRESIDENT OF AN AUCTION HOUSE

WORST FASHION FAUX PAS?

TRYING TO HAVE A STYLE.

INES LIKES...

This look displays iron-clad composure.

MY CUFFLINKS ARE VERY PLAIN. I DON'T LIKE COMPLICATED THINGS.

THE KILLER DETAIL

A well-worn shirt.

STYLE ICON

I don't have a style icon, but I admire the style of **Hubert de Givenchy**.

BEST STYLE TIP

Less is more.

I love the Neapolitan brand E. Marinella.

ELEGANT

GEORGES, ATTORNEY

MY FASHION FETISH

Wanting to wear pajamas!

INES LIKES...

The striped suit is worn with a cane for even more poise.

THE BONUS DETAIL

THE RIBBON OF THE ORDER OF GRAND OFFICER OF THE FRENCH LÉGION D'HONNEUR.

If I had to describe my style, I'd say "ironically uptight."

SMART THINKING

Looking like you didn't give it a <u>second thought</u>.

MY STORES

CHARVET
charvet.com
> For suits and shirts.

J.M. WESTON
jmweston.com
International delivery available

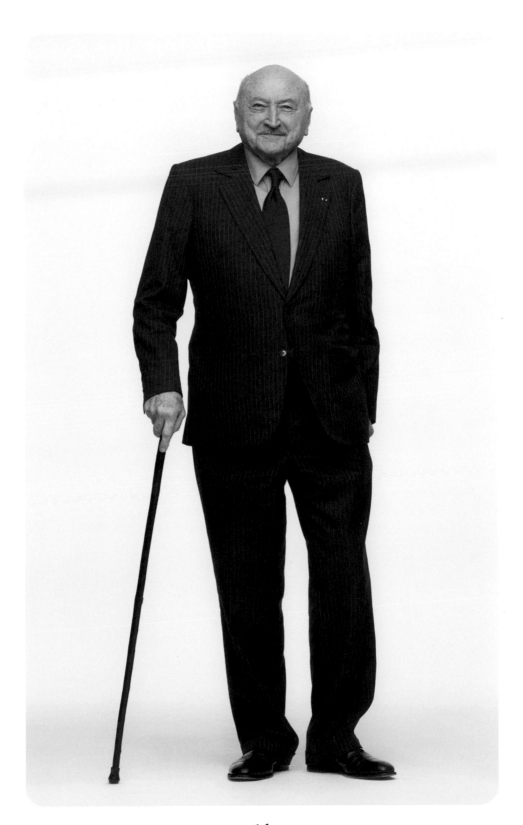

61

CLASSIC BUT CUTTING-EDGE

ÉRIC, FASHION DESIGNER

I'm a designer, so I know my shortcomings and I adapt my style accordingly. I like the idea of a uniform. I dress more and more in navy and in dark colors, rarely in beige or light gray.

INES LIKES...

A sweater worn with a suit in navy blue creates instant style.

STYLE ICON

Cary Grant had real magnetism.

SMART THINKING

When choosing clothes don't forget that **you gain weight over the years**.

WORST FASHION FAUX PAS?

Wearing a size smaller than you actually are.

MY STORE

SMALTO
smalto.com
> This store has retained the atmosphere of a tailor's shop as it was in the 1970s. It's a legendary brand and I've just become its artistic director.

PARIS EXCLUSIVE

MY FASHION FETISH

<u>A crew neck sweater with a shirt</u> underneath or a polo shirt worn as a top.

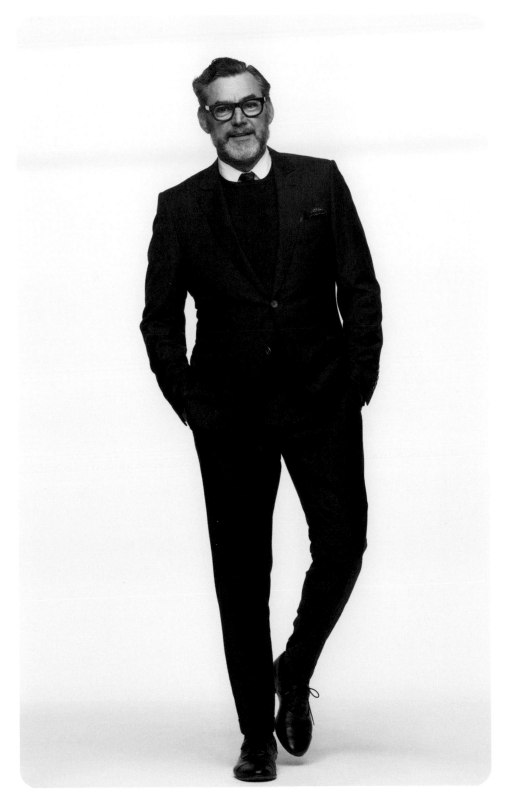

COOL STUDENT

JOSEPH, STUDENT

My style? Inexpensive but effective.

INES LIKES…

A sheepskin jacket worn over denim is totally cool.

I CAN'T LIVE WITHOUT

A denim
or navy blue shirt.

BEST STYLE TIP

Don't follow fashion.

STYLE ICON

Steve McQueen had a crazy style, but not just because of his clothes.

THE BONUS DETAILS

Belts are important.
And **hems**, don't sew hems.

MY STORE

JINJI
jinji.fr
> Everything here is ultra stylish. In particular, they sell great Japanese denims.

WORST FASHION FAUX PAS?

Overalls and **loafers with tassels**.

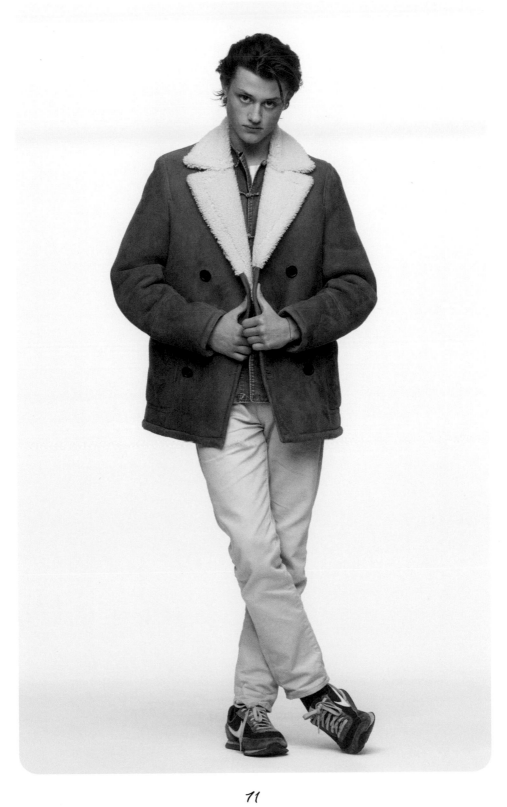

11

TRIM & SPORTY

CHAD, STUDENT

Shoes. They can alter a whole outfit.

INES LIKES...

I love the white jeans worn with a tracksuit top.

My style? The newest member of The Sopranos.

STYLE ICONS

In terms of style I like both hip-hop artist Rejjie Snow and stylist Sam Jarou.

WORST FASHION FAUX PAS?

Suspenders
and small hats.

BEST STYLE TIP

Try to innovate.

MY STORE

GUERRISOL
guerrisol.fr
> For vintage clothes. I also like shopping at flea markets.

The soccer shirt is a key item in my wardrobe.

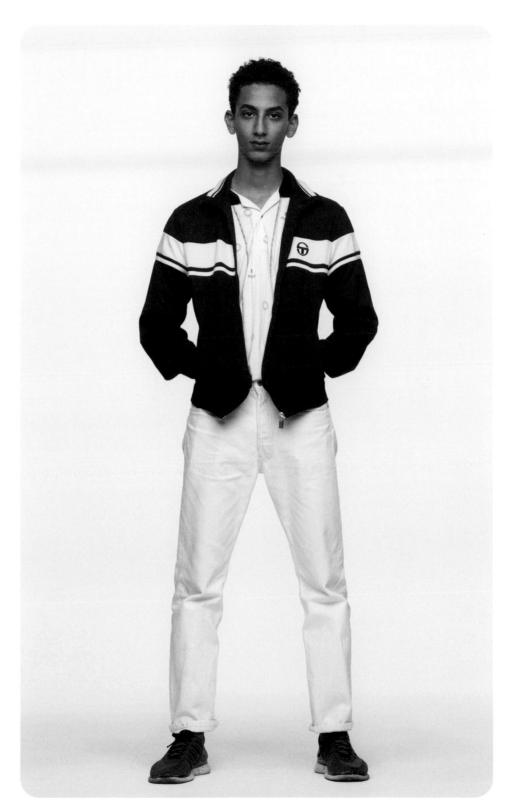

ECLECTIC STYLE

BENJAMIN, SECRET AGENT

Because of my job, I change my style often to blend into different environments, morphing from the most sophisticated to the most ordinary.

THE KILLER DETAILS

The cellphone case worn on a belt, of course! More seriously, a watch can be original or rare, shoes can have a personalized patina, and even a pair of sneakers can be a collector's item.

STYLE ICON

Steve McQueen
is a timeless male style icon.

INES LIKES...

It's daring to wear a colored shirt with denim, but you need to keep the rest of the outfit very plain.

I DON'T LEAVE HOME WITHOUT

Jeans.

PRACTICAL ADVICE

My worst style faux pas was an oversight a short while ago. On the same day, I had to change from jeans and sneakers to a suit and tie. Unfortunately, I hadn't thought about socks for the formal outfit: my white ankle socks protruded above my black dress shoes when I was sitting down. I hated myself all day.

MY STORES

PRINTEMPS
printemps.com

CITADIUM
citadium.com

ZARA
zara.com
International delivery available

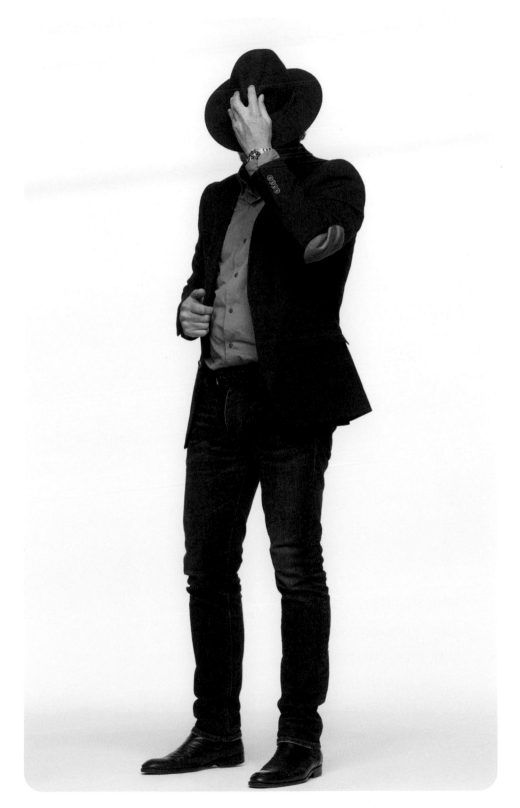

15

FRENCHY

SIMON, OUTSTANDING STUDENT

I'm a Frenchman and proud of it!

INES LIKES...

This is French style inspired by the era of movie star Jean Gabin. I love the fact that he's knotted the belt of his coat, instead of buckling it.

THE KILLER DETAIL

Polished shoes and an **ironed shirt**.

STYLE ICON

Charles de Gaulle had a lot of style.

I CAN'T LIVE WITHOUT

My **tank top** (Petit Bateau or Monoprix).

BEST STYLE TIP

Lose twenty pounds!

WORST FASHION FAUX PAS?

Not changing your boxers!

It isn't always easy to get dressed in the morning, as my natural tendency is to be naked.

MY STORE

CHEZ AMMAR
65, rue Nollet, Paris 17ᵉ
> A vintage store whose owner is full of good advice.

PARIS EXCLUSIVE

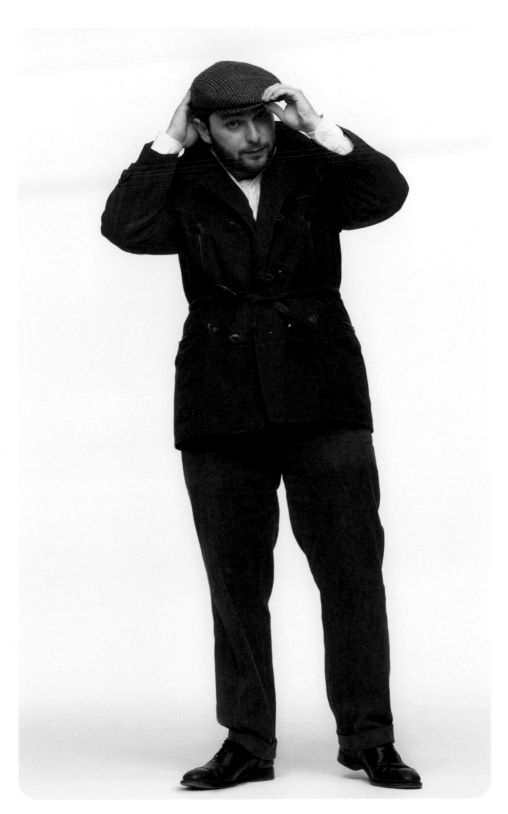

11

FORMAL CASUAL

ROUZBEH, BUSINESSMAN

THE KILLER DETAIL

A watch. It can express everything: a sense of humor and personality.

INES LIKES…

I love the suit worn with a pocket square but without a tie.

I always mix luxury brands with other much more casual clothes.

I CAN'T LIVE WITHOUT

A shirt, it's a man's 4x4.

My style is casual, but sleek. Nothing is important, but actually everything is. I have to feel comfortable as I wear a suit for up to sixteen hours a day.

BEST STYLE TIP

Be **consistent**. In your mood, desires, and also in the face of different opportunities.

STYLE ICONS

Fiat heir **Lapo Elkann** and singer **Pharrell Williams**, in the present. **Oscar Wilde**, in the past.

MY STORES

HACKETT
hackett.com
International delivery available
> For truly British style.

DIOR
dior.com
International delivery available
> For elegance.

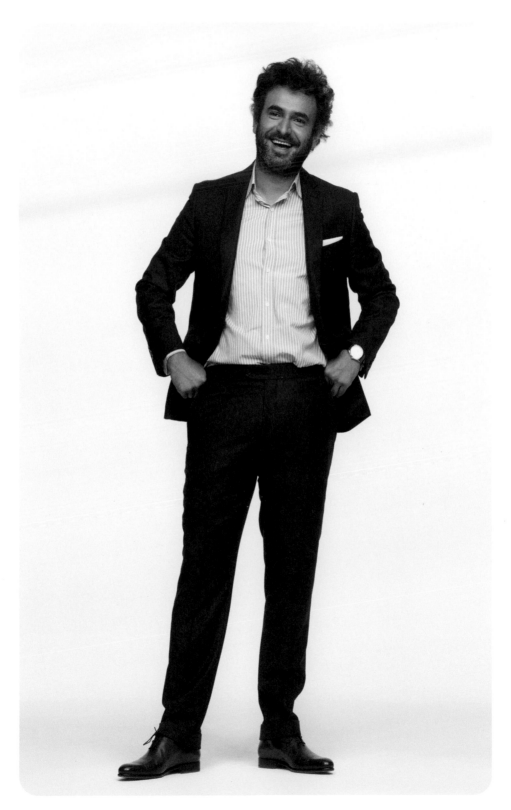

79

CLASSIC COOL

ANTON, STUDENT

MY FASHION FETISH

I always button
the top button on my shirt.

INES LIKES...

Turtleneck + blazer + jeans
+ sneakers = a perfect cocktail!

I often wear baseball caps, as I really hate combing my hair.

BEST STYLE TIP

Never wear more
than three colors!

WORST FASHION
FAUX PAS?

Wearing more
than three colors.

STYLE ICON

Lewis Hamilton's
style is great.

I can't
live
without
my
**Gap
jeans.**

MY STORE

THE KOOPLES
thekooples.com
International delivery available

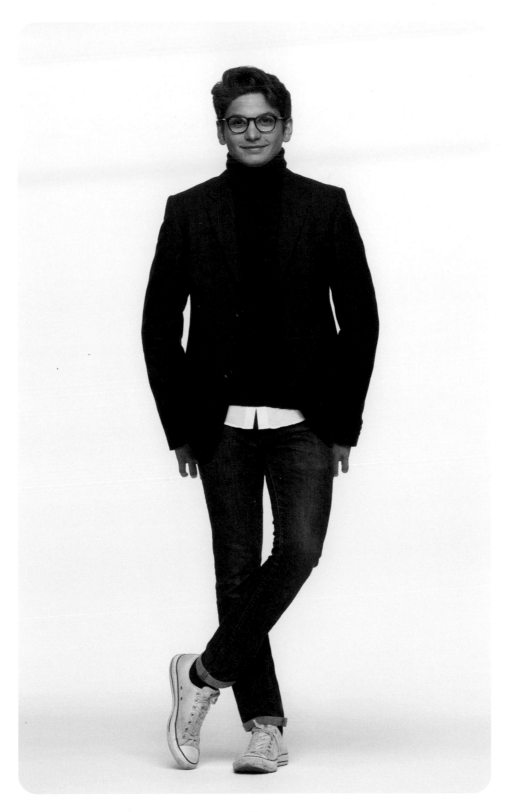

SHARP & STYLISH

KEVIN, ATTORNEY

I don't have an essential item of clothing because 'the things you own, end up owning you.' You might think this quotation is by the Dalai Lama, but actually it's a paraphrase of a quote from Chuck Palahniuk's novel, Fight Club: 'And the things you used to own, now they own you.' Still, it's worth re-reading the Dalai Lama!

BEST STYLE TIP

When I was around five years old, my mother told me never to go out completely naked. It was a piece of advice that was appropriate and useful, and I still swear by it every day.

THE KILLER DETAIL

Wearing an item of clothing or accessory that has **a sentimental value**.

INES LIKES…

A white shirt worn with a dark suit creates a flawless look.

STYLE ICON

I've always enjoyed studying **John Lennon's** style. Along with the other Beatles, he gave the impression that he wanted his clothes to convey a message: teenage rebellion with his leather jacket; charm with his collarless suit; unbridled creativity with his vibrant *Sgt. Pepper* jacket; antimilitarism with the US Army jacket he wore at the start of the 1970s.

WORST FASHION FAUX PAS?

Never making a fashion faux pas is the worst faux pas (sounds like something Ines would say, right?).

MY STORE

AGNÈS B.
agnesb.com
International delivery available

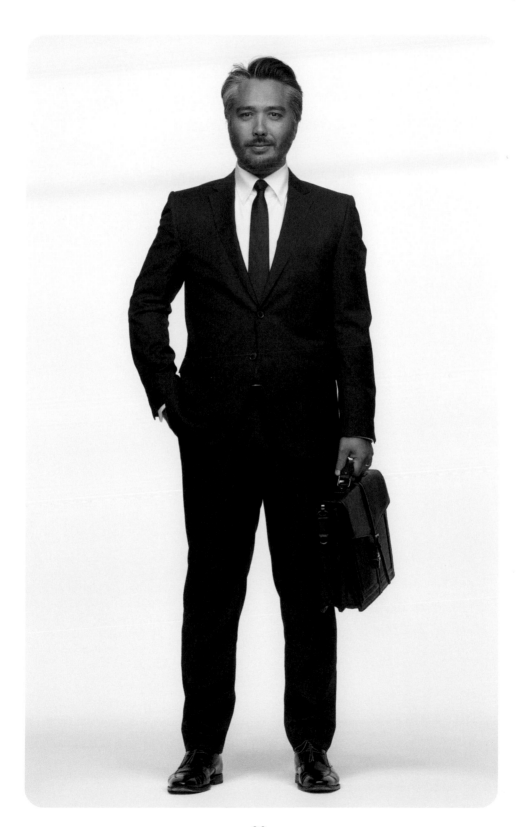

THE SCIENCE OF STYLE

YVES, ANTHROPOLOGIST

I don't have a style, or if I do it's a <u>style by omission</u>. I'm interested in mankind before clothes were even invented.

STYLE STORIES

I'm not overly attached to clothes. One time, I was flying back from Tunisia and my wife was waiting for me at the airport. She gave me a strange look and said, "That's not your jacket." I had taken the wrong jacket out of the overhead luggage compartment. I probably never would have noticed, if my wife hadn't told me.

I've been advised never to wear short-sleeve shirts in Paris. It seems that this is forbidden.

STYLE ICONS

Cro-Magnon Man, who always wore well-groomed animal skins. And Ötzi the Iceman, the glacier mummy who was found at an altitude of 10,000 feet and who was wearing furs and leather shoes 5,000 years ago.

WORST FASHION FAUX PAS?

When I lived in Africa, I bought a **purple suit**. Apparently, it was **truly awful**. Or an unevenly tied tie. I think it's sad when it's **too short**, or when it's **too long** and doubles as a fig-leaf.

MY STORE

STARK & SONS
starkandsons.com
International delivery available
> This tailor made my ceremonial costume as a member of the Académie Française.

I love cufflinks. When scientists are in the lab and don't have anything to fix the cuffs on their shirt, they have been known to use a stapler. I don't.

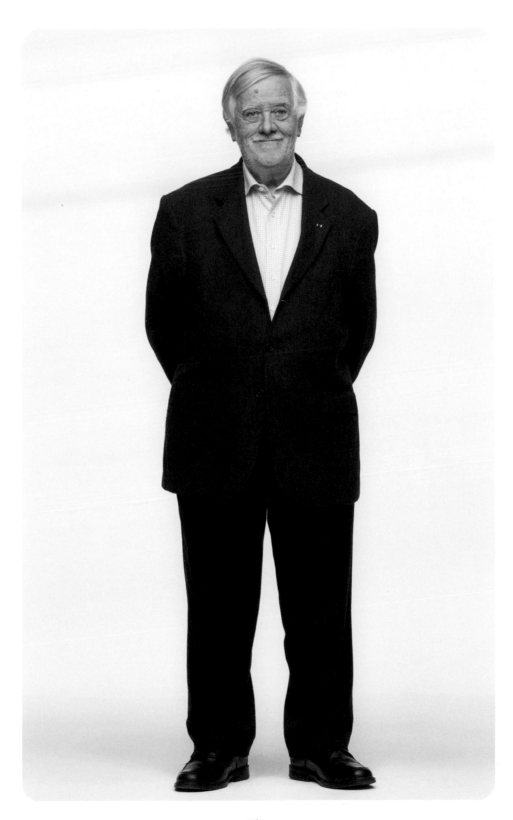

85

AMERICAN FRENCHY

VALENTIN, HAIRDRESSER

I'm "off-trend."

INES LIKES...

It's "Made in the USA" without going cowboy from head to toe. And I love the ethnic necklace, a keepsake from his wife.

THE KILLER DETAIL

The way your beloved looks at you.

STYLE ICONS

A cross between **Alain Delon** and **Keith Richards**.

WORST FASHION FAUX PAS?

Clothes that have been aged artificially. The wear and tear must be real. There's nothing worse than jeans that have been made to look distressed by a machine.

MY FASHION FETISH

Polishing my boots. I also take them to the cobbler at À La Ville À La Montagne (3, boulevard Richard-Lenoir, 11e; alaville-alamontagne.com). He repairs my boots perfectly and creates special polishes.

AZZEDINE ALAÏA ONCE SAID TO ME, "NEVER CHANGE YOUR LOOK." I'VE MAINTAINED THIS AMERICAN STYLE SINCE THE 1960S OR '70S.

MY STORE

> Rockmount Ranch Wear (rockmount.com; international delivery available), a boutique in Colorado where you can buy wonderfully authentic Western shirts.

MY MUST-HAVES

Levi's 505 jeans. I look out for them all the time. And Ariat boots (ariat.com). For me they're as comfortable as sneakers.

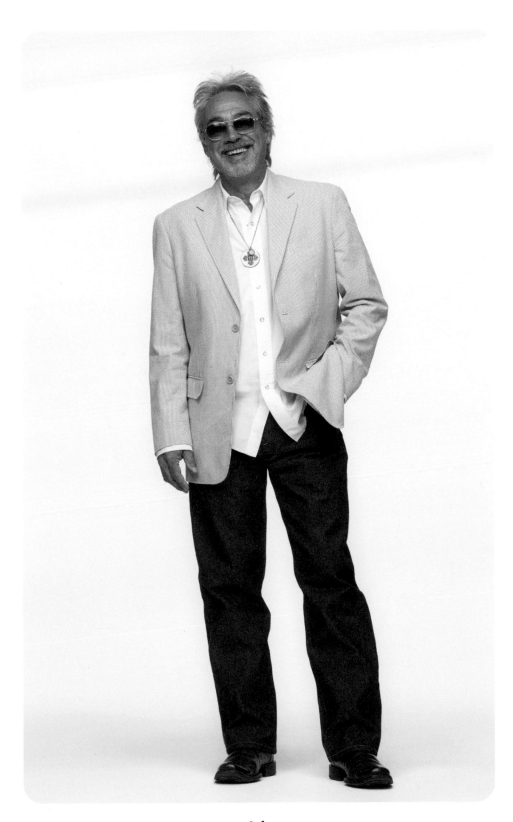

COOL & SLEEK

HERVÉ, JOURNALIST

I never wear more than three colors.

INES LIKES...

A chunky navy blue sweater with raw denim is a great winter uniform.

THE KILLER DETAIL

My watch. I change it all the time. I have a drawer with fifteen watch compartments. The sixteenth replaces the least good among the fifteen.

MY FASHION FETISH

I have all my clothes altered. Even swimwear.

STYLE ICON

I admire **David Beckham** who didn't have an innate sense of style, but who has succeeded in becoming a real icon.

I love mixing up clothes and offsetting one piece against another. I often wear a casual jacket with pants from a suit. Or a collared shirt with well-worn jeans.

WORST FASHION FAUX PAS?

A short-sleeve, collared shirt. If it's hot, roll up your sleeves!

MY STORES

ÉCLECTIC
e-eclectic.com
> Traditionally cut clothes made from high-tech materials.

HERMÈS
hermes.com
International delivery available
> At this store, you can just drop in for coffee. I ride horses, so I love browsing the riding equipment with my son.

88

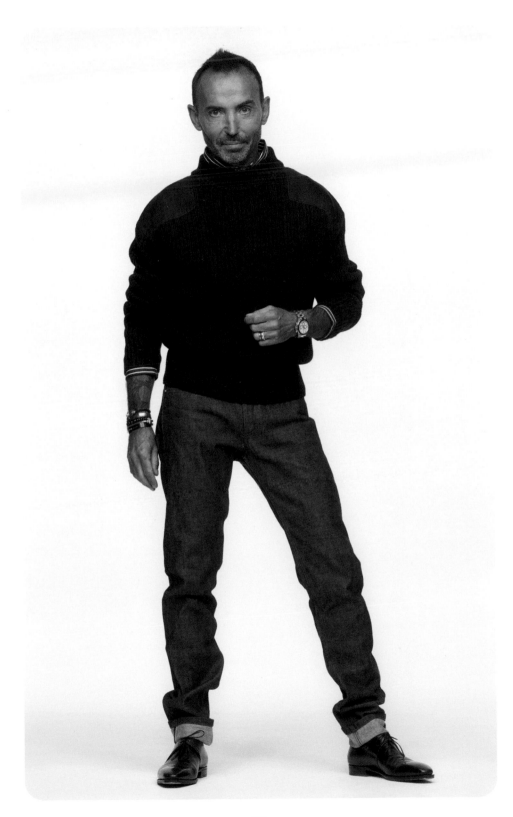

SOBERLY STYLISH

HERVÉ, ATTORNEY

A navy blue suit worn with a white shirt creates a look of wonderful simplicity.

MY FASHION FETISHES

Wearing a wool vest under a jacket or suit. And always wearing a white shirt under my official robes when I'm in court.

I'm sorry that tailor Max Evzeline's store no longer exists. I'm passionate about the work of craftsmen.

BEST STYLE TIP

Avoid pointless showing-off—dressing like a dandy, for example.

WORST FASHION FAUX PAS?

Wearing three-quarter pants with short socks patterned **with the likes of cartoon speech bubbles.**

THE KILLER DETAIL

The notches on the lapels of a jacket.

STYLE ICONS

I admire the styles of both **King Hassan II of Morocco** and the Italian actor **Lino Ventura**.

MY STORES

MAISON COURTOT
113, rue de Rennes, Paris 6ᵉ
maison-courtot.com
> The perfect place to buy shirts.

PARIS EXCLUSIVE

MR PORTER
mrporter.com
International delivery available
> I love shopping at night.

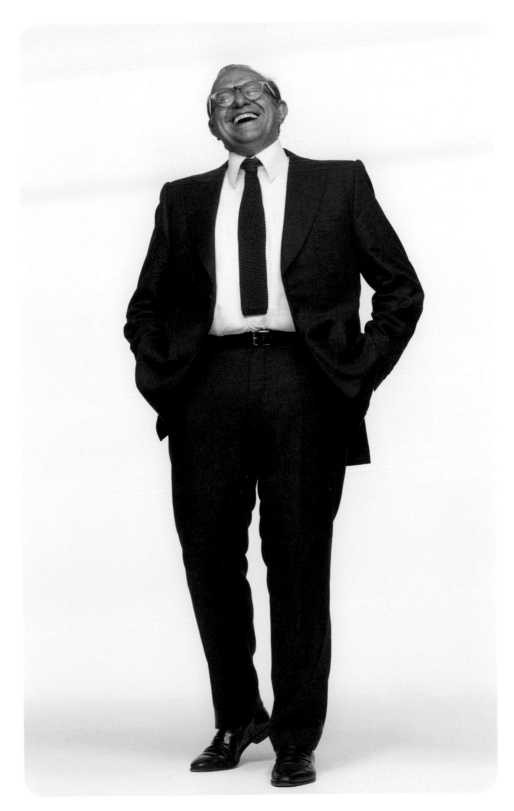

ARTY BRITISH

ANTHONY, PAINTER

My style is rather English: it's colorful with a mixture of fabrics. I particularly like combining two colors in velvet.

I DON'T LEAVE HOME WITHOUT

I'm a big fan of cufflinks.
And colorful ties.

STYLE ICON

Irishman **Garech Browne**, who is a wonderfully bold and eccentric dandy.

WORST FASHION FAUX PAS?

Wearing **jeans**
or **shorts**.

Never copy other people. Always be yourself.

I CAN'T LIVE WITHOUT

My tuxedo, which was made by Hardy Amies, Queen Elizabeth's dressmaker.

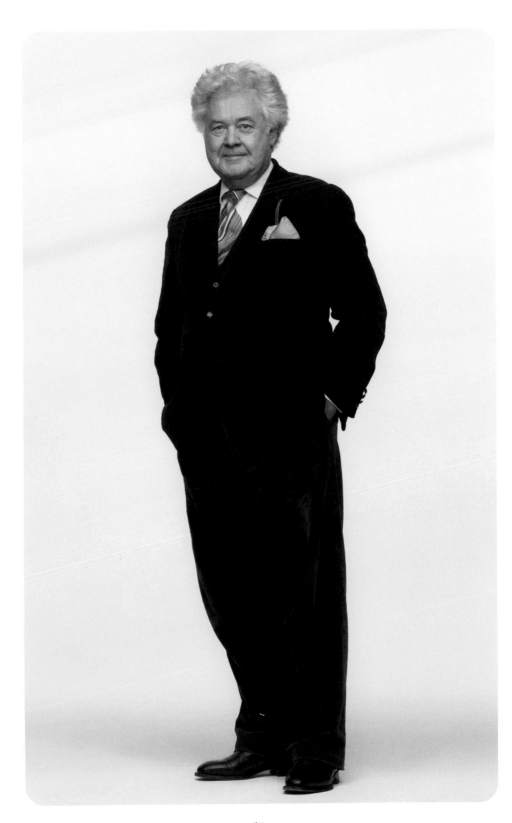

CITY STYLE

ALEXANDRE, STUDENT

MY FASHION FETISH

White T-shirts. I buy them at Levi's, Calvin Klein, and Uniqlo.

INES LIKES...

A lumberjack shirt works well with a bomber jacket and dress shoes.

FEELING GOOD IS THE BEST WAY TO BE STYLISH.

WORST FASHION FAUX PAS?

Wearing white socks off the tennis court.

I don't really have a style. Perhaps improvised city style. Sometimes I strike it lucky. In any case I never do anything deliberately. Plus, I'm color-blind, so any color-matching is purely accidental.

THE KILLER DETAIL

Glasses. Mine are by Lafont (lafont.com).

STYLE ICON

I admire **Jacques Chirac's elegance**.

MY STORES

VICTOIRE
monvictoire.fr

BRUNELLO CUCINELLI
shop.brunellocucinelli.com
International delivery available

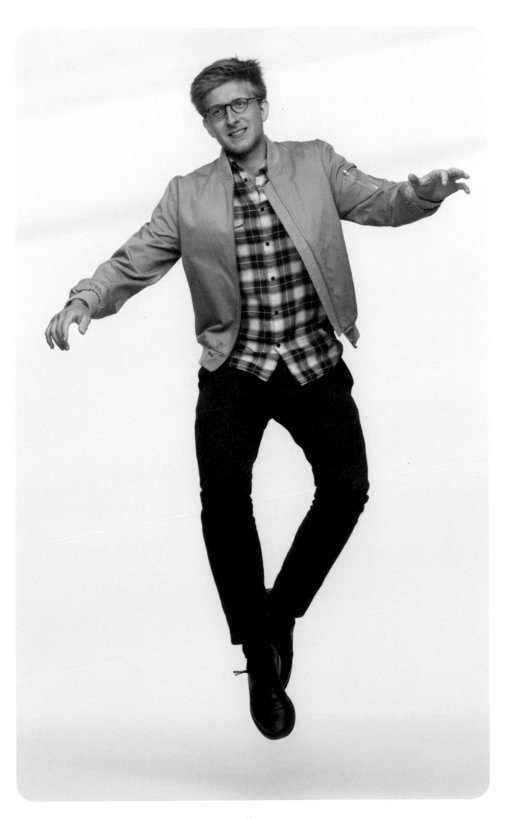

COOL ETHNIC

BENOÎT, PHOTOGRAPHER

I'm still **desperately** seeking **my own style**.

MY FASHION FETISHES

Turbans and Indian shirts.

THE KILLER DETAIL

Rodolphe, my assistant.

The coat I'm wearing in the photo was hanging on the wall of a Chinese restaurant like a work of art. I offered to buy it, and they agreed.

I CAN'T LIVE WITHOUT

My army jacket and a white shirt.

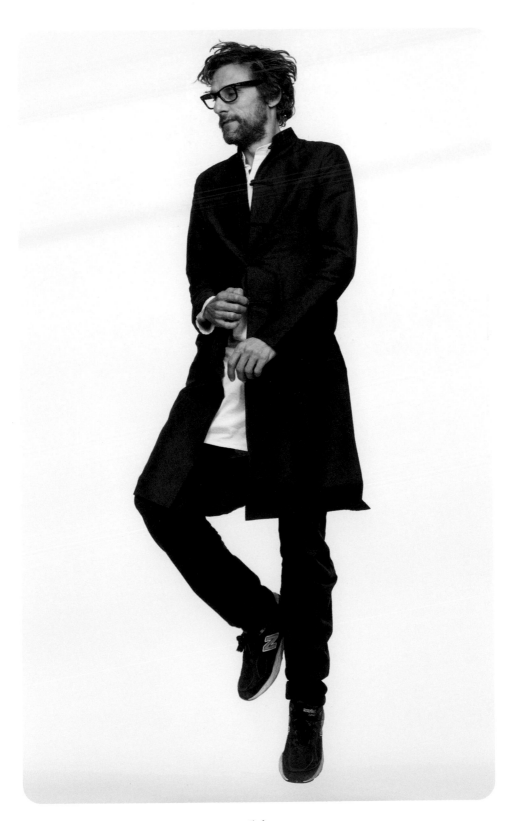

SOFT ROCK

MATTHIAS, PRODUCER

I have a non-style. I'm practical above all else. Even though my wife works for a fashion brand!

A leather jacket worn with sneakers but also with canvas pants creates a great look.

MY FASHION FETISH

I'm useless when it comes to colors, but I can wear any shade of blue like no one else. And I scrub up in no time at all.

WORST FASHION FAUX PAS?

For years I wore a leather jacket which was much too heavy. It was neither comfortable, nor attractive. I kept it for ten years because it was expensive.

STYLE ICON

Pierre Niney is an actor who really knows how to dress well.

MY MUST-HAVE

I always wear Zadig & Voltaire's generous, soft **Tunisian T-shirts**. They're really comfortable.

MY STORE

AGNÈS B.
agnesb.com
International delivery available
> For suits, jackets, and T-shirts.

I like to see other people wearing a great scarf.

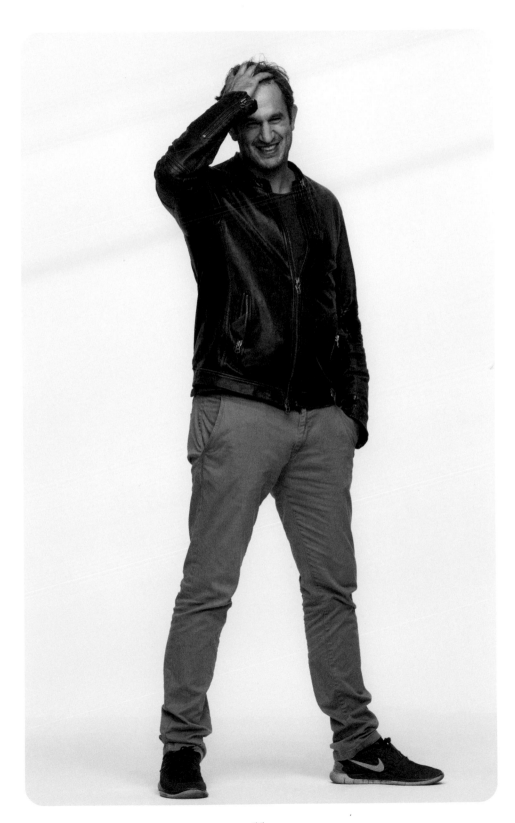

ARTISTIC

GÖSTA, PHILOSOPHER AND DANCER

WORST FASHION FAUX PAS?

Bermuda shorts
and colored socks.

INES LIKES…

Sometimes it's worth
daring to combine
distinctive, eccentric
pieces (striped pants
with a red velvet jacket).

STYLE ICON

I like the audacious
attitude of dancer
Rudolf Nureyev.

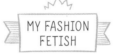

**MY FASHION
FETISH**

Fragrance. I've been
wearing Acqua di
Parma since I was
sixteen years old.

THE KILLER DETAIL

Double cuffs.

*I'm classic but with a little
inspiration. I like wearing
clothes that fit snugly.*

MY STORE

AGNÈS B.
agnesb.com
International delivery available

BEST STYLE TIP

My grandmother always told
me you should keep your nails
clean and smell good.

CLASSIC CHIC

GRÉGOIRE, INVESTMENT BANKER

In winter I can't live without my <u>scarf</u> (Etro) and in summer my <u>swimming trunks</u> (Vilebrequin and Orlebar Brown).

INES LIKES…

Navy blue suit + light blue shirt + black tie = stylish simplicity.

Every day I wear a belt or suspenders. And every day of the week I'm in my tasseled shoes (Alden).

WORST FASHION FAUX PAS?

Wearing too many colors, and doing up your top button when you're not wearing a tie. A tank top that's visible under your shirt—that's not very stylish either.

I DON'T LEAVE HOME WITHOUT

I've been wearing **the same watch** (Hermès) for thirty years. I just change the strap.

BEST STYLE TIP

Keep your beard well trimmed.

STYLE ICON

James Stewart was incredibly classy in Alfred Hitchcock's movies.

MY STORES

CHARVET
charvet.com

ETRO
etro.com
International delivery available

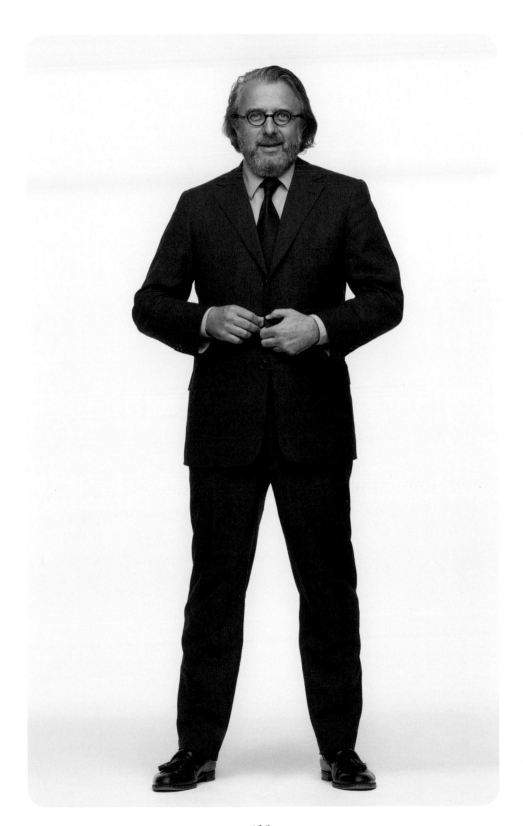

109

URBAN ETHNIC

HAIDER, FASHION DESIGNER

I can't really say what my style is. I don't think about it too much: it's just what I happen to put on in the morning.

STYLE ICONS

A cross between Pasolini, Visconti, David Bowie, Keith Richards, and the King of Bhutan.

THE KILLER DETAIL

Having **clean hands.**

MY MUST-HAVE

I always wear a large scarf. It protects me: I can hide behind it.

BEST STYLE TIP

Accept **your shortcomings.**

I don't wear skinny jeans, and I would find it hard to wear those <u>plastic clogs with holes</u>.

MY STORES

RALPH LAUREN
ralphlauren.com
International delivery available

BERLUTI
berluti.com
International delivery available

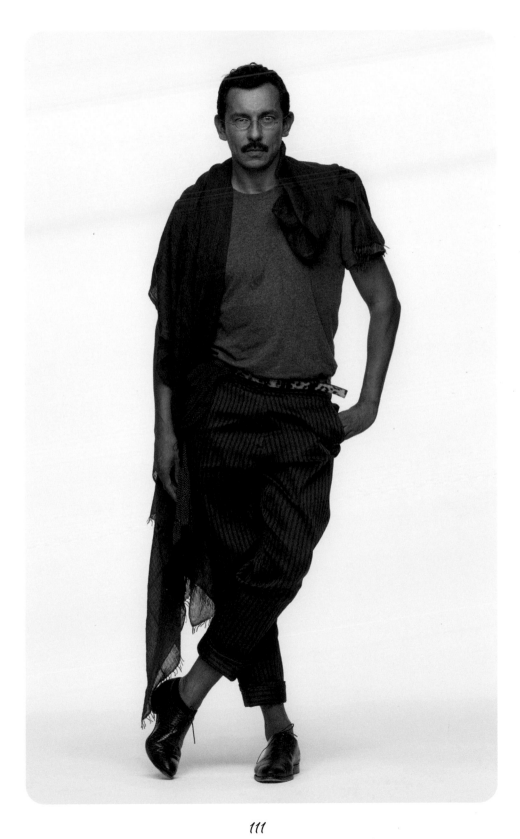

SIMPLE YET STYLISH

ALAIN, NOTARY

On the weekends, I live in jeans with a polo shirt or a sweater.

INES LIKES…

The simplicity of the suit is jazzed up with the stylish patterned tie.

MY MUST-HAVE

My Christian Dior tie.

STYLE ICON

Jude Law—I love his understated look.

MY FASHION FETISH

I collect cufflinks.

IN MY LIFE I FOLLOW THE "RULE OF FOUR 'S'S"

✓ Serious about work.
✓ Straightforward with my friends.
✓ Simple in what I wear.
✓ Surprising in love.

I wear navy blue a lot. **And never with other colors**.

MY SUIT IS MY UNIFORM, BECAUSE I DON'T HAVE TIME TO THINK ABOUT IT IN THE MORNING.

MY STORES

PRADA
prada.com
International delivery available

DIOR
dior.com
International delivery available

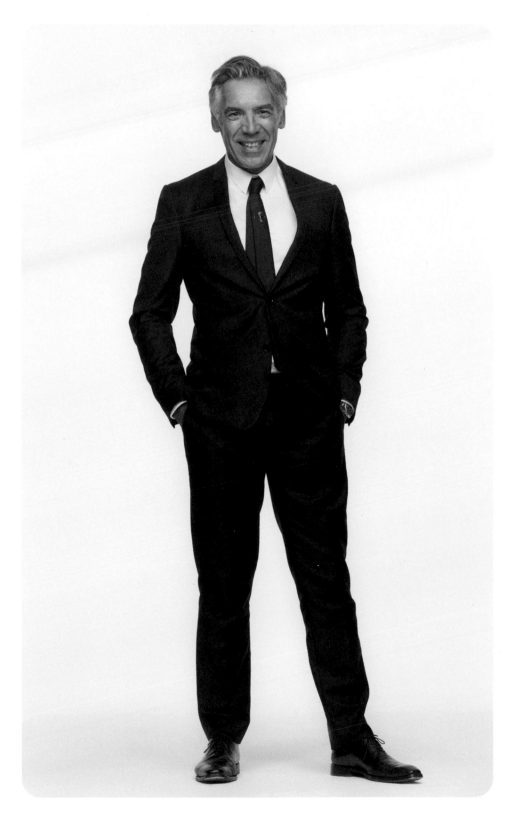

PATTERN JUNKIE

ELIE, FASHION DESIGNER AND JEWELER

I prefer to **play around with the rules** rather than break them. I have a uniform of jacket, shirt, and tie, which I liven up with patterns (stripes, checks, prints, jacquard fabrics, etc.). **Everything mixed up together**.

STYLE ICONS

Writer Thadée Klossowski, Gary Cooper, James Joyce, and David Hockney.

BEST STYLE TIP

Christian Lacroix once wrote to me quoting Jean Cocteau: "What the public criticizes you for, cultivate it. It's you!" That applies to everything.

WORST FASHION FAUX PAS?

Being fashionable!

MY STORES

HILDITCH & KEY
hilditchandkey.co.uk
International delivery available
> For shirts and pajamas.

DRIES VAN NOTEN
driesvannoten.com
> For jackets and shirts.

HERMÈS
hermes.com
International delivery available
> For ties and pants.

PRADA
prada.com
International delivery available
> For ties and shirts.

RALPH LAUREN
ralphlauren.com
International delivery available
> For shirts.

JOHN LOBB
johnlobb.com
International delivery available

J.M. WESTON
jmweston.com
International delivery available

A.P.C.
usonline.apc.fr in the US or apc.fr/wwuk
International delivery available
> For all their jeans and corduroys.

LIBERTY
libertylondon.com
International delivery available
> For print shirts.

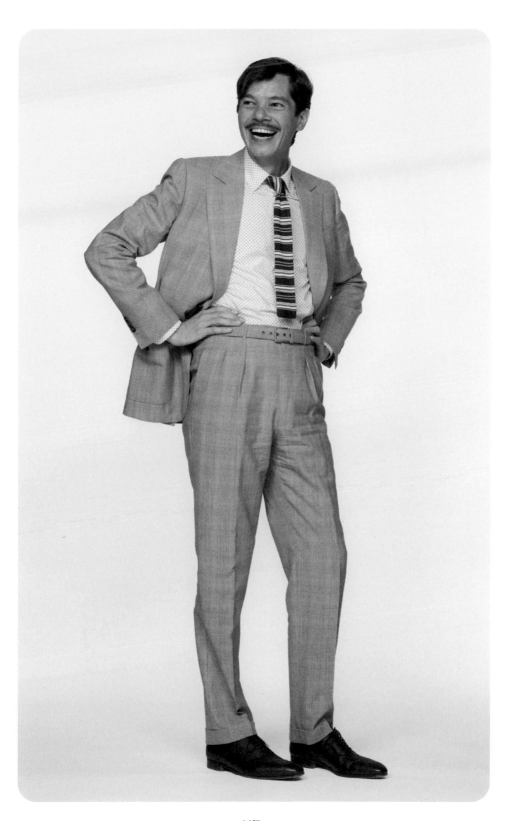

BASIC CHIC

LAURENT, ATTORNEY

Shoes provide an elegant touch.

A suit worn without a tie wins you a few points on the cool-ometer.

I DON'T LEAVE HOME WITHOUT

I always wear Prada's soft, stretch <u>poplin shirts</u> in light blue and white. And navy or gray suits.

WORST FASHION FAUX PAS?

A short-sleeve, collared shirt!

MY FASHION FETISH

I never wear a tie.

STYLE ICON

Tom Ford
has a great style.

MY STORE

PRADA
prada.com
International delivery available

My style is relatively classic.

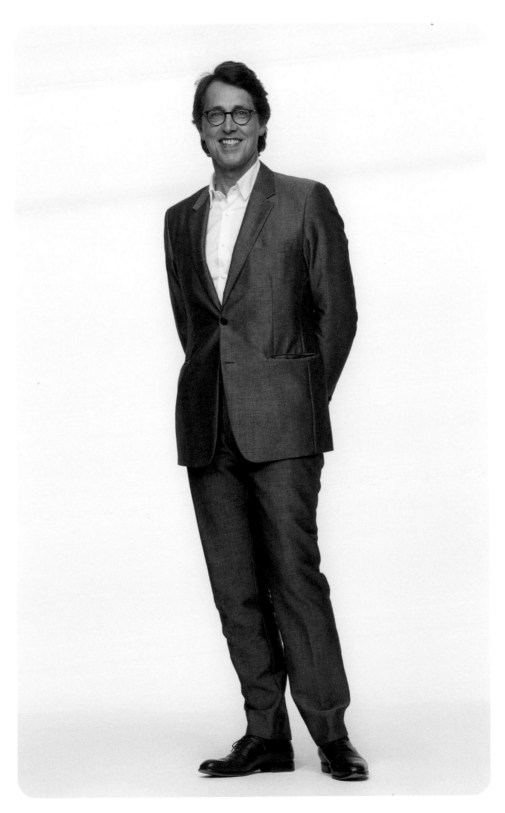

REGAL STYLE

EMANUELE FILIBERTO, PRINCE AND BUSINESSMAN

THE KILLER DETAILS

✓ The quality of fabric. I have a thing about always feeling fabrics.

✓ Pocket squares. I buy mine in Italy, India, and Japan.

✓ I love craftsmen. Because of my background, I try to buy my clothes in Italy. I support Italian craft, especially small leather manufacturers.

INES LIKES...

I love the personal detail of these shoes with their highly individual patina.

WORST FASHION FAUX PAS?

Brown shoes with a blue suit. And a tank top worn under a buttoned-up shirt.

My Berluti shoes have a design on the side, which is exactly the same as the design I have tattooed on my body.

I CAN'T LIVE WITHOUT

I'm a fragrance addict.
Mine is by Kilian (bykilian.com), but I'm in the process of creating a fragrance under my own brand.

STYLE ICONS

I've never noticed other people's style. I don't have fashion style icons, but instead lifestyle icons such as **Paul Newman** and **Steve McQueen**.

MY MUST-HAVE

Jacob Cohen's denim.

MY STORE

SCAPPINO
scappino.com
> The Italian tailor by appointment to my grandfather, the last king of Italy.

My style is classic and very personal. I haven't changed it since I was seventeen. I'm not into fashion at all. I like wearing jeans and a T-shirt (I have my own collection of T-shirts called Prince Tees) or bespoke suits by Borrelli, a Neapolitan tailor.

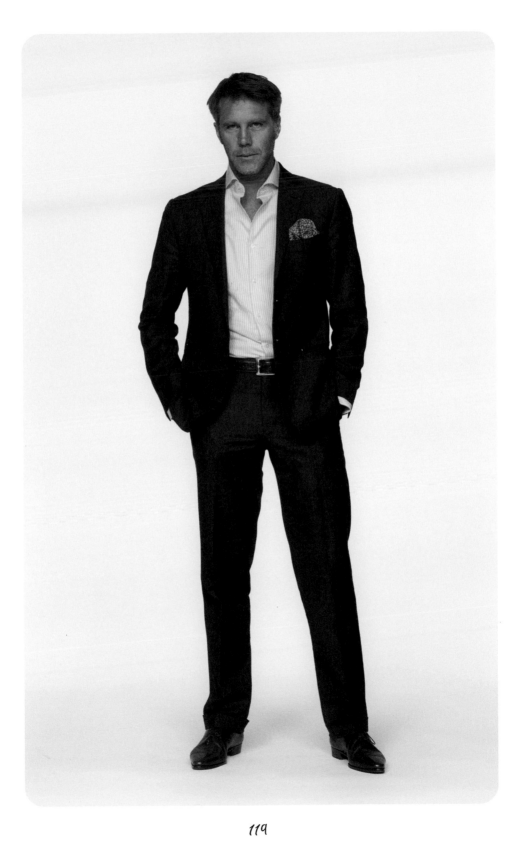

119

FUN CHIC

BRUNO, FASHION DESIGNER

Wearing clothes shouldn't be pretentious. I like a sense of humor: it's important to know how to be elegant and fun. Be desirable rather than detestable.

INES LIKES...

This look is almost classic except for the "surfer" detail of the shoes (by Prada nevertheless!).

MY FETISH

Putting my hands in my pockets makes me feel like I'm improving my build.

THE KILLER DETAIL

Shoes.

WORST FASHION FAUX PAS?

Being a clothes horse.

BEST STYLE TIP

Don't be a clothes horse.

STYLE ICON

David Hemmings in *Blow-Up*.

I CAN'T LIVE WITHOUT

The **Tanger T-shirt** by Yves Saint Laurent.

MY STORES

DRIES VAN NOTEN
driesvannoten.com

LANVIN
lanvin.com
International delivery available

ITALIAN FRENCHY

PATRIZIO, CREATIVE DIRECTOR AND COMPANY DIRECTOR

My style? Bold!

INES LIKES...

An Italian blazer worn with a brightly colored sweater and white jeans is a bold Italian combination.

BEST STYLE TIP

I've met lots of men with unique personalities and styles. It's inspired me to be true to myself.

I CAN'T LIVE WITHOUT

White jeans.

STYLE ICON

Michael Jackson.

WORST FASHION FAUX PAS?

Not owning your look.

MY FASHION FETISH

I never throw out any of my clothes.

THE KILLER DETAIL

Good-quality fabrics and an excellent cut.

MY STORES

ERMENEGILDO ZEGNA BY ALESSANDRO SARTORI
zegna.com
International delivery available

FENDI
fendi.com
International delivery available

MR PORTER
mrporter.com
International delivery available

How to look
Parisian

(everything you ever wanted
to know about style)

ENEMIES
of style

Even though it's only fashion and the kind
of pants you wear won't save any lives,
there are still some basic rules to follow if you
want to be one of those guys with impeccable
style. From three-quarter pants to outdated
shirts, here's what *not* to wear.

TANK TOP
+ THREE-QUARTER PANTS

This top may have looked sexy on Patrick Swayze in *Dirty Dancing*, but that was a long time ago and he was on the dance floor. As a general rule, anything that resembles a sleeveless T-shirt is outlawed, particularly if there's a slogan on the front. Of course, if you're going running, I'll allow it. But combined with three-quarter pants and sandals—absolutely not.

BASEBALL CAP
WORN BACKWARD

Do we really need to talk about baseball caps worn back-to-front? Of course not. Any normal guy knows that a backward baseball cap = dopey teenager. It's up to you, but even rappers seem to have given up on this look.

A PRINT SHIRT

Shirts with overly realistic prints (like the stork-like birds shown here) might pass for entertainment at a kid's birthday party—but that's it.

A HEAD SCARF

No comment. . . .

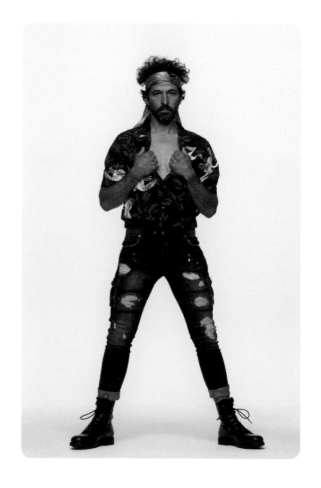

RIPPED JEANS

No, no, no. If you've worn out your jeans yourself over the years, that's fine, but new jeans specially made with holes look fake.

COMBAT BOOTS

If you're not in a punk band or the Army, forget 'em.

128

BERMUDA SHORTS

Did I already mention that bermudas are forbidden? They may be acceptable on the beach when it's one hundred degrees in the shade, but away from the sand this article of clothing does no one any favors. It's better to wear jeans, chinos, or even swimming trunks. Have you ever seen a Parisian wearing shorts in the city? No? Well there you go.

THE COMPLETE LOOK

Scarf at the neck, boat shoes with white socks—any of these fashion faux pas would make a bona fide Parisian girl run for the hills. And even more verboten is the sweater tied over the shoulders. Either check the weather before leaving home, or carry your sweater. I can forgive a sweater tied around the waist, but draped over the shoulders is the height of unsexiness.

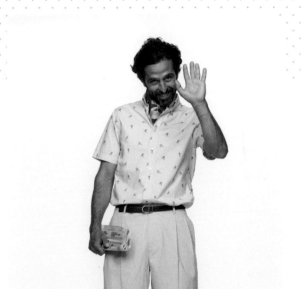

UPTIGHT PREPPY

SHORT-SLEEVE COLLARED SHIRT

Quelle horreur! Either roll up the sleeves of your long-sleeved shirt or wear a T-shirt.

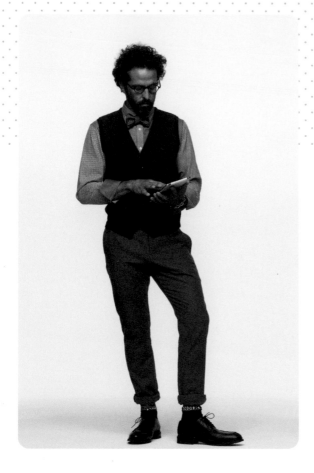

PRINT SHIRT +
BOW TIE + VEST +
OVERLY-TAILORED
PANTS = RECIPE FOR
DISCOMFORT

We could write a whole chapter on the bow tie. Except when it's worn with a tuxedo, this accessory lacks a certain je ne sais quoi when it comes to masculinity. Clearly, some hipsters have taken to it, but for it to work, the rest of the look has to be über-hip and the guy has to be sporting a beard. Or be a member of the Collège de France. In short, avoid getting stuck in an overly square look.

PRINT SHIRT
AND VEST

Avoid shirts that are a melting pot of multiple prints. The vest is not a bad idea, but in this case undo a few buttons and wear with denim.

SWEAT PANTS

It bears repeating: don't leave home in sweats if you're not on your way to work out. Generally, Parisians get changed in the locker rooms of their gyms. They always find the time to do this, as walking the streets of the capital in these shapeless pants is not acceptable to any self-respecting Parisian guy.

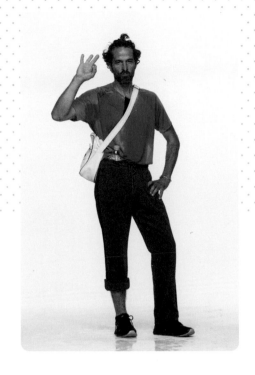

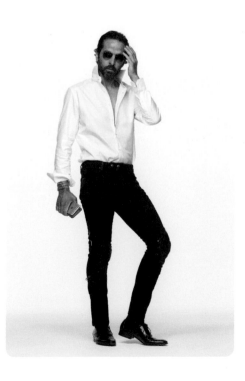

SEXY ROCKER

WHITE SHIRT
+ BLACK SKINNY JEANS

For everything there is a time. If you're twenty and searching for your own style, you can give black skinny jeans (never leggings) with a white shirt a whirl. But over a certain age, this combination looks like a costume. Of course, if you work in the fashion world, you have an excuse.

THE BASICS
for looking good

If you want to look like the Parisian in-crowd, here are a few recommendations.

IMPORTANT
DETAILS

✗ *If you're a fan of espadrilles,* only wear those with stitched toes. As for colors, go for <u>navy blue</u>, <u>black</u>, or possibly <u>sea-blue</u>. Avoid pink, purple, or sea-green hues.

✗ *Avoid baseball caps.* This is <u>absolutely not a Parisian look</u>!

✗ *Your tie* should always stop at the right spot, just above the center of your belt buckle. Too long or too short and you'll just look <u>like a fool</u>.

✗ *Think carefully when choosing your belt:* it should have the <u>same patina as your shoes</u>, if you're wearing a suit. If you're in sneakers, it should be wide-ish.

✗ *A belt* with a big logo is like leaving the price tag on a garment. Absolutely not chic.

✗ *Totally forbidden*: white socks with pool sliders. Yes, I know you know, but it doesn't hurt to repeat it, to prevent any risk of sliding down the slippery slope of bad taste.

✗ *Carrying a backpack when wearing a suit.* Some will claim they have a medical condition which means this is the only way they can tote their computer. But there has to be a better solution—a New York-style courier bag, for example.

✗ *A watch* and—perhaps—*a wedding ring* are the only items of jewelry you need. Gone are the days of flaunting your wealth with rings and necklaces encrusted with precious stones. If you really want to wear a rock'n'roll-style bracelet, OK, but not if you work in a bank. It will always make you look less professional.

✗ *A beret* is quintessentially French. I've always thought it was the perfect accessory for shepherds in the French Resistance during the war. But it has no business adorning the head of any cool, stylish Parisian man today. Parisian girls, on the other hand, can wear a beret any way they like.

✗ They may be practical, but plastic *flip-flops* are still made of <u>plastic</u>.

✗ *Boat shoes* are fine in <u>sailing resorts</u>. Anywhere else, and you risk capsizing your whole look.

✗ *Little canvas sneakers* are for <u>toddlers</u> only.

✗ What about *square-toe shoes?* Apart from the fact that you might be mistaken for a mafioso, it's difficult to find them in luxury shoe stores. <u>Enough said</u>.

ALL ABOUT
COLOR

Black is strictly for priests.
No man wants to look like <u>he's in mourning</u>.

Not a lot of people know this,
but a tuxedo should be midnight blue.

White socks are for tennis and *tennis only.*
All the guys in this book agree: white socks
are unacceptable with dress shoes.

This one's not just a Parisian rule,
but a global rule, too: *never wear more than three
colors at the same time.*

A black shirt may seem like a good idea,
but truly it's not. <u>It drains the color</u>
from your face.

OUT-OF-DATE
OUTFITS

✗ Throw out all your *briefs*. Only superheroes still wear them.

✗ Get rid of the *fake pocket square* from the breast pocket of your jacket. If it's fake, it will look fake.

✗ Throw out all your shirts with *roll tabs* on the sleeves.

✗ *Fleeces* belong on the ski slopes (and even then…). Under no circumstances should they be worn in town, or even in the ski village. Fleeces are designed to keep you warm. In no way do they make you look hot.

✗ *Parkas with a fur-trim hood* belong in Canada. Wear one in Paris and you could be mistaken for Nanook of the North stranded in the big city.

✗ *Cargo pants* in the twenty-first century make you look like an extra from the movie *Hibernatus*. For those unfamiliar with Louis Funès's film, imagine a man frozen in a block of ice for several decades and completely cut off from the march of fashion. Cargo pants are so '90s!

✗ A *pink rugby shirt.* I have no idea where this idea that you can wear a rugby shirt without ever having been near a rugby ball originated. In traditional families rugby shirts can be personalized to create a kind of uniform for bachelor parties. This is the rugby shirt's one and only function: as a costume.

MAKING A GOOD
IMPRESSION

✗ *Don't wear T-shirts emblazoned* with pictures if you are over eighteen. The only possible exception is when you're at a concert to prove you're a fan.

✗ Whether in a print or a single color, *a shirt should be made of one fabric*. That means cuffs in a different color are out.

✗ *Don't be a walking billboard!* A huge logo on a T-shirt or sweatshirt is just tacky.

✗ *Don't go overboard when it comes to pattern!* Some of the men in this guide like to combine print fabrics. These guys are all creatives who have a certain reputation in the fashion world and who have a duty to display their creativity. However, unless you're a fabric designer, it's not a good idea to mix polka dots with stripes.

✗ Pants with stripes? A seersucker jacket? A check shirt? These are all possible, but *one at a time, please.*

SMART THINKING

Don't button up your suit all the way. Always leave the bottom button undone. Don't ask me why, that's just the rule! Some people say it was a habit of King Edward VII, who was a little too stout to do up the last button. Perhaps. But in any case, it's obviously more pleasant for everyone!

✦

When wearing a suit, *wear socks that are mid-calf length or longer.* No one wants to see hairy calves when you cross your legs. Man may be descended from the apes, but he should avoid demonstrating this at work.

STYLE
dilemmas

Some questions
remain unanswerable.
Not these ones.

Is it still possible
to wear a beige suit?

Up to what age can
I wear a hooded
sweatshirt?

Yes, if it's made of linen
or cotton and you wear
it in summer. But avoid
wearing beige in winter.
What can it be worn
with? A white shirt.

If it's to go jogging, you have all the excuses in the world.
But worn by anyone over thirty, the hooded sweat screams
Peter Pan syndrome. A jacket does the job very well, or a
sweatshirt without a hood, if you're really into sportswear.

Are some types
of cufflinks unacceptable?

Yes, the kind of "fun" cufflinks that aren't really fun at all when worn
with a suit. For example, those inscribed with a five-speed gear shift
or Scrabble letters, cufflinks bearing messages ("May the force be
with you" or "If found" on one and "Return to wife" on the other),
or those really bizarre cufflinks that are designed to surprise
(a Lego block or the ESC key on a computer). Always be plain
and discreet. At most, you can put your initials on your cufflinks,
and if you want colorful links, look for those made of a fabric knot.

Is it ok to wear stonewashed blue jeans?

Er, no. Raw denim or slightly faded jeans are fine, but very light-blue or stone-wash rockets us back to the 1980s and George Michael singing *Careless Whisper*. To be avoided.

Pink socks: are they ever acceptable?

If you're Italian, there's absolutely no problem (Gallo makes some very attractive ones). In Paris and elsewhere, they're a little more difficult to carry off. It's up to you: do you want to stand out from the crowd and see "la vie en rose"?

Tricky. But if you're wearing just a print shirt, and everything else is plain (dark-colored chinos, suede loafers), it can work. And it must absolutely be the height of summer. And definitely not a short-sleeve shirt. Ethnic print or no, a short-sleeve shirt is liable to be used in evidence against you in the divorce courts.

Is it OK to wear African prints if you don't live in Nairobi?

142

Should skinny jeans be outlawed?

When you're seventeen, at high school, going for the rocker look, and you're thin and a Mick Jagger fan, skinny jeans have their uses. When you're between thirty and forty, it borders on pathetic. And not particularly attractive. Did James Stewart or Cary Grant wear skinny jeans? Even George Clooney and Brad Pitt don't wear them.

What about a tattoo?

The question is: are you sure you'll never regret it? Will you be able to camouflage it at your next job interview? Even if you have a cool job, a huge skull tattooed on your forearm is not the greatest look. My advice is to go for "Ines forever" and when you're tired of that you can turn it into "HappInes forever."

Is it acceptable to wear leather pants?

It all depends: do you hang out with Lenny Kravitz? If all your friends live in Paris's tony 16e or 8e arrondissements, forget it.

Four-in-hand

> Easy, everyday knot

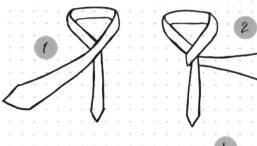

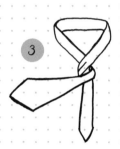

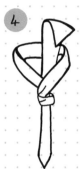

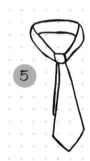

Kelvin knot

> Double knot for shirts with Italian collars

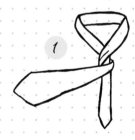

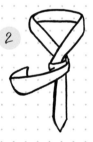

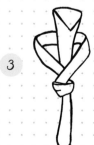

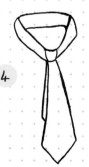

Kent knot

> A discreet knot for narrow ties

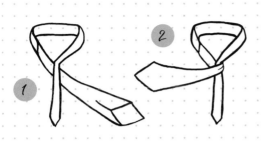
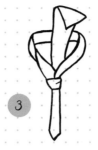
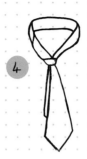

Old Bertie

> More substantial than a four-in-hand and less formal than the full Windsor

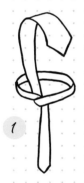
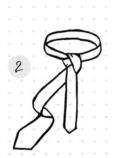
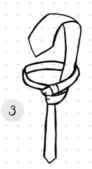
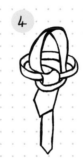
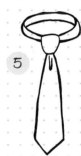

Full Windsor

> For formal occasions

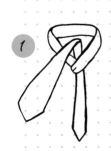
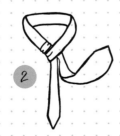
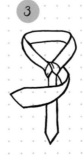
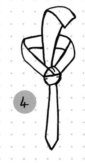
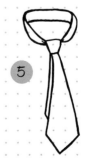

THE PERFECT
wardrobe

You bought this book (or received it as a gift) because you want to know what a Parisian man's wardrobe looks like. It's easy: with these fifteen pieces, you can deal with any situation Paris may throw at you.

No need to gallop around innumerable stores if you want to revamp your wardrobe: the fifteen essentials on the following pages are all available on the multibrand website mrporter.com (international delivery available).

AN OVERCOAT
NAVY BLUE

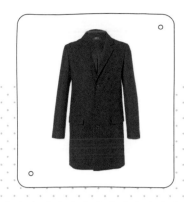

A BOMBER JACKET
NAVY BLUE, KHAKI, BEIGE, OR GRAY

A SUIT
NAVY BLUE

A WHITE **SHIRT**

A LIGHT BLUE **SHIRT**

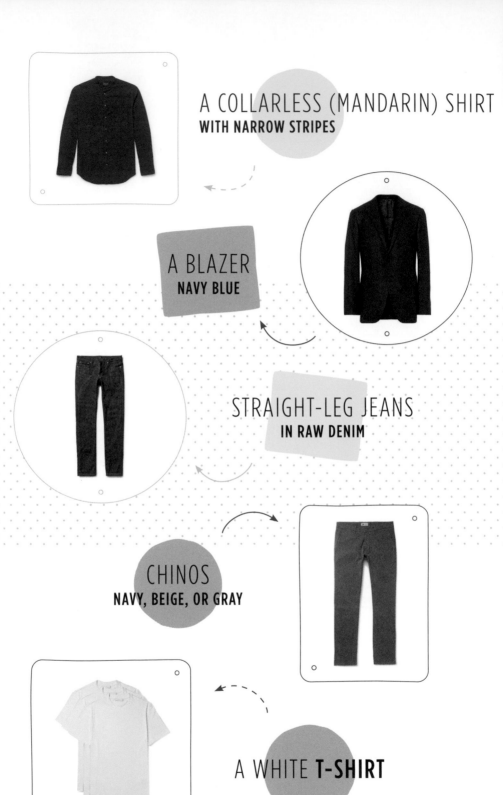

A COLLARLESS (MANDARIN) SHIRT
WITH NARROW STRIPES

A BLAZER
NAVY BLUE

STRAIGHT-LEG JEANS
IN RAW DENIM

CHINOS
NAVY, BEIGE, OR GRAY

A WHITE **T-SHIRT**

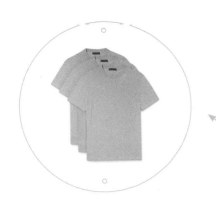

A GRAY **T-SHIRT**

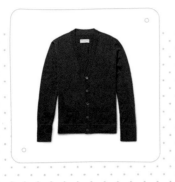

A TURTLENECK
SWEATER
GREY

A JACKET
NAVY BLUE

BLACK **DERBIES**

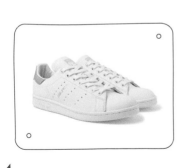

SNEAKERS

(Any brand is possible—this is how you choose your style tribe. From Stan Smiths by Adidas to 373s by New Balance, there's a whole world to choose from!)

TIME FOR
style

To add the finishing touch to their look, girls have It bags and guys have watches. Whether an expensive timepiece or a gadget you can change as often as your shirt, the most important thing is that your watch tells you the time. Here are ten models that are as timeless as they are timely.

SUBMARINER

ROLEX

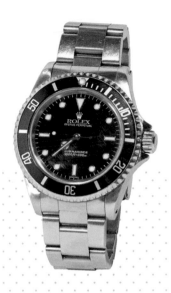

Created in 1953. This watch is waterproof to three hundred feet (100 m), but it's very useful in town as well. It gives the wearer a sporty style.

How to wear it? With jeans and a shirt.

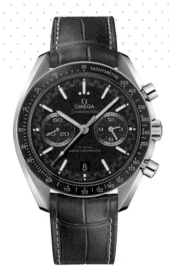

SPEEDMASTER

OMEGA

Nicknamed "the Moonwatch," because Buzz Aldrin wore it to walk on the moon on July 21, 1969. Its various sub-dials are a dream for every adventurer.

How to wear it? With chinos and a T-shirt.

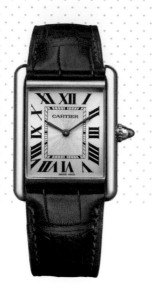

TANK

CARTIER

Launched in 1919 and inspired by the assault tanks of World War I, the Tank owes its star quality specifically to its clean lines and dial—either square or rectangular. John F. Kennedy owned one.

How to wear it?

With a suit.

REVERSO

JAEGER LECOULTRE

How to wear it?

With jeans if the dial is visible, and with a suit if it's reversed.

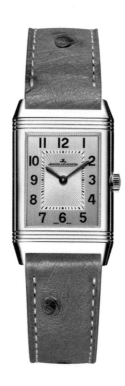

A British army officer wanted to play polo wearing a watch that was shock-resistant. Jaeger LeCoultre solved the problem by creating this model whose dial could be protected by flipping it over. Watch out: women love the Reverso and can very easily "borrow" it from you.

ROYAL OAK

AUDEMARS PIGUET

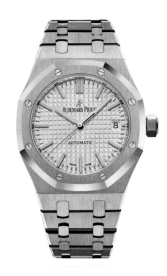

The first stainless-steel watch, it has an octagonal dial decorated with eight hexagonal screws. This is an all-terrain watch that transitions smoothly from a sporting to a work environment. The Royal Oak is a real investment: it's been very popular since the 1970s, so it's easy to sell on if you go bankrupt.

How to wear it?

With jeans, with a suit, with swimming trunks: it goes with absolutely everything.

ALTIPLANO

PIAGET

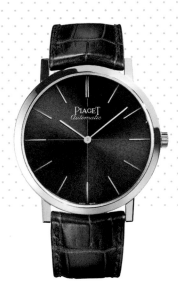

This is one of the world's flattest watches, and one of the most streamlined. Created in the 1990s, it's a classic that can easily be passed down the generations due to its timeless style.

How to wear it?

With everything: it makes any outfit look elegant.

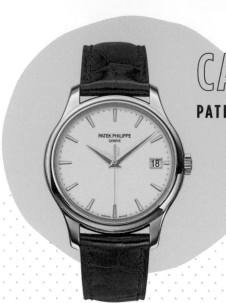

CALATRAVA

PATEK PHILIPPE

Always the height of discretion, a Patek Philippe is not recommended for those who like to show off. Launched in 1932, the Calatrava is no exception to the rule: it combines clean lines and restrained elegance with pure luxury.

How to wear it?

This is a watch for eveningwear, in particular, with a suit. Worn with jeans it makes an unusual statement, but this, too, has its charm.

GENT

SWATCH

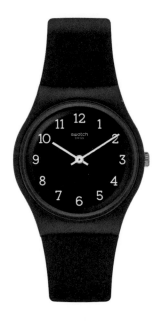

This first model by Swatch was launched in 1983. It's unisex and above all uni-style: it can be worn with absolutely everything. Of course, the Blackway and the Blueway stand out as the must-have models in the range—particularly in light of their oh-so-affordable price.

How to wear it?

I know guys who wear it with a suit. It's daring, but it creates a certain look.

BIG CROWN

ORIS

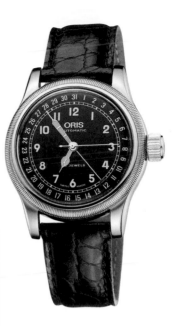

How to wear it? With jeans or chinos while traveling.

For aviation enthusiasts, it's the Oris that soars above the rest. With its oversized winding crown, it allowed aviators of the past to wind and adjust their timepiece easily while wearing leather gloves. Today, there's nothing to stop you from taking it for a spin on an Airbus A380.

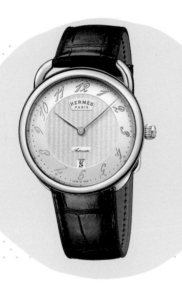

ARCEAU

HERMÈS

How to wear it? With a suit.

This was the first watch created by the Hermès ateliers. Clearly inspired by the equine world, its attachments recall the stirrups on a horse's saddle. It's hard to imagine a more classic watch.

Stylish
addresses

PARISIAN STYLE
in store

I know. As a rule, men don't really like shopping. But you do have to buy clothes sometimes. For great menswear, Parisians wander along avenue Montaigne (Dior and Prada are still popular stores) or in the direction of boulevard Haussmann (the department stores Galeries Lafayette and Printemps are goldmines when it comes to checking out all the brands). But you can perfect your Parisian look without the hassle, because most brands are available online. To help you navigate, here's a selection of brands that can create style with a single article of clothing.

Ami

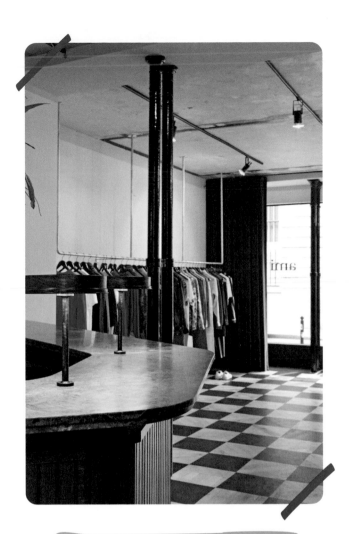

THE STYLE

Clothes that contemporary guys can wear every day. They're simple but always with an inventive touch or an edgy cut that makes all the difference. It's an easy, elegant style that girls love. The store is very close to my own—I fell in love with one of their sweatshirts. If you live with a girl, watch out, as garments from Ami have a habit of migrating over to the opposite side of the wardrobe.

THE MUST-HAVES

Perfectly cut chinos.
And the gray, embroidered Ami T-shirt.

How to sound like a regular?

"Has Alexandre been in today?"
(Alexandre Mattiussi is the brand's designer and a really nice guy.)

ADDRESS

22, rue de Grenelle, Paris 7ᵉ
Locations worldwide

ONLINE STORE

amiparis.com
International
delivery available

Marchand Drapier

Marchand Drapier's designers describe their style as completely French—sharp tailoring with splashes of bright color. They're not afraid of prints and the occasional ethnic touch.

THE MUST-HAVE

The print shirt.

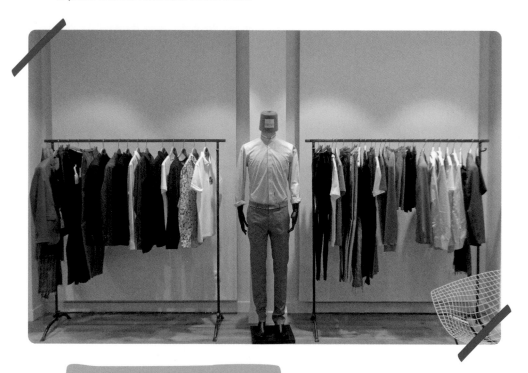

How to sound like a regular?

"Marchand Drapier is famous for its fusion tailoring."

ADDRESS

4, rue Madame, Paris 6ᵉ

ONLINE STORE

marchand-drapier.com

Maison Standards

Through their revolutionary concept of a transparent distribution chain, this brand operates without agents, and so their margins can be slashed in half. This means their prices are very reasonable. And the clothes are always timelessly stylish.

THE MUST-HAVES

Oxford shirts, T-shirts, bomber jackets, chinos—these are all must-haves that will never go out of fashion.

How to sound like a regular?

"In a traditional store you'd pay double for this shirt. What do the fashion police think about that?"

ADDRESS

25, rue de Poitou, Paris 3e

ONLINE STORE

maisonstandards.com
International
delivery available

The Broken Arm

ADDRESS

12, rue Perrée, Paris 3ᵉ

ONLINE STORE
the-broken-arm.com

International
delivery available

THE STYLE

Balenciaga, Vetements, Isaac Reina, Comme des Garçons—it's designer wear only in this multibrand store, with characterful pieces you don't usually find elsewhere. The Broken Arm is a temple for all cutting-edge designers.

THE MUST-HAVE

The pants—all of which are highly original.

How to sound like a regular?

"It's great because they have lots of clothes you can't find anywhere else— and also because they have *burratas* and bresaola on the lunch menu."

Gabriel Paris
(formerly Églé Bespoke)

THE STYLE

Come here for a look that is totally your own, as everything is bespoke! The shirts are really popular: you can choose from thousands of fabrics and even order personalized buttons. At more affordable prices, you'll also find a ready-to-wear line and dandy-style garments, including seersucker suits and lots of bow ties, for those who like that kind of thing.

THE MUST-HAVES

Here, the must-haves are made especially for you. The bespoke jeans deserve a special mention. If you still haven't found your perfect fit, this is the store for you.

PARIS EXCLUSIVE

ADDRESS

26, rue du Mont-Thabor, Paris 1ᵉʳ

ONLINE

facebook.com/maisongabrielparis

Paul Smith

THE STYLE

One hundred percent British style with a playful touch. A dandy with a sense of humor wears Paul Smith.

THE MUST-HAVE

"A Suit to Travel In" is perfect to take on the road, as it's made in crease-resistant fabric.

How to sound like a regular?

"I love Paul Smith's new Dino print and I've even downloaded the Dino Jumper game to play on my cellphone."

ADDRESS

223, rue Saint-Honoré, Paris 1er

ONLINE STORE

paulsmith.com
International delivery available

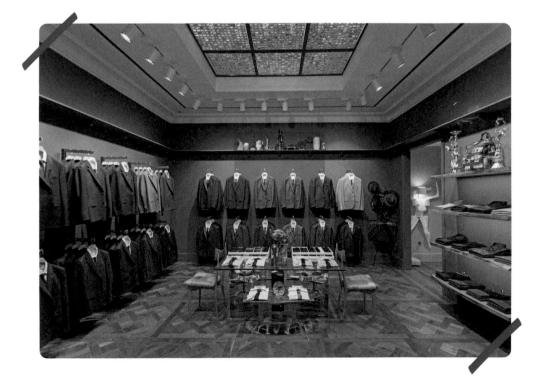

Officine Générale

The brand's designer, Pierre Mahéo, creates clothes for everyday wear in beautiful fabrics at affordable prices. It's my favorite kind of simple, less-is-more fashion.

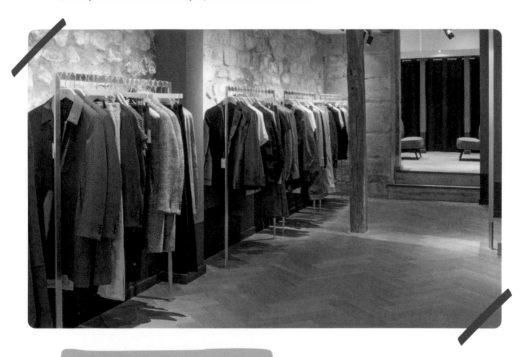

How to sound like a regular?

"It's really great that they've launched a womenswear range."

THE MUST-HAVES

The navy blue Antime shirt and the Nina sweater in merino wool.

ADDRESS

6, rue du Dragon, Paris 6ᵉ

ONLINE STORE

officine-generale.com
International delivery available

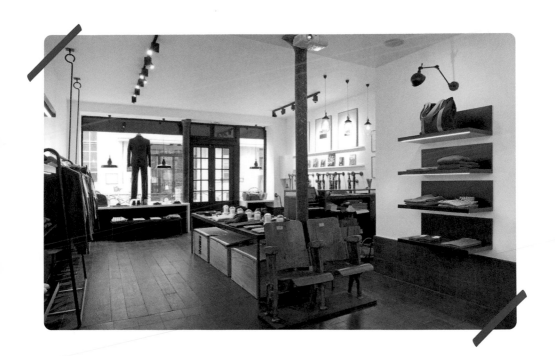

Balibaris

THE STYLE

"A good mix of modern basics to make you stand out from the crowd and a new take on the classics. It's this subtle balance of stylish details and timelessness that defines Balibaris's perfect positioning in the market." Paul Szczerba, the founder of Balibaris, has found the right formula for attracting men who want clothes that are both modern and timeless.

ADDRESS

14, rue de Marseille, Paris 10ᵉ

ONLINE STORE

balibaris.com
European delivery available

THE MUST-HAVES

The City jacket and pants;
the Mitch T-shirt and the Jay shirt.

How to sound like a regular?

"And to think that the entire brand started with a collection of ties!"

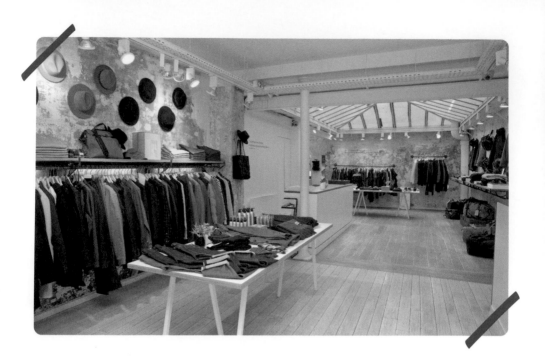

Centre Commercial

Launched by the founders of the socially responsible brand Veja, this multibrand store (for women and children too) only sells brands that show commitment. All are highly transparent in their production processes. Best of all, they offer basic clothes that you can wear all your life without tiring of them.

THE MUST-HAVES

Veja sneakers and a raincoat by Swedish brand Stutterheim.

How to sound like a regular?

"Centre Commercial isn't a store, it's a movement!"

ADDRESS

2, rue de Marseille, Paris 10ᵉ

ONLINE STORE

centrecommercial.cc
International delivery available

Maison Kitsuné

THE MUST-HAVE

The T-shirt with the "Parisien" slogan, because sometimes it's good to pin your colors to the mast.

ADDRESS

18, boulevard
des Filles-du-Calvaire, Paris 11e
Locations worldwide

ONLINE STORE

shop.kitsune.fr
International delivery available

THE STYLE

The basic idea of founders Gildas Loaëc and Masaya Kuroki was to bring music and fashion together. Illustrating the point where France and Japan meet, their look offers pieces that are clearly inspired by our time, all of which are must-haves for up-to-the-minute Parisian style. When I have a moment, I like to drop in to Café Kitsuné (51, galerie Montpensier, Paris 1er).

How to sound like a regular?

"'Kitsuné' means 'fox' in Japanese, in case you couldn't tell from their logo!"

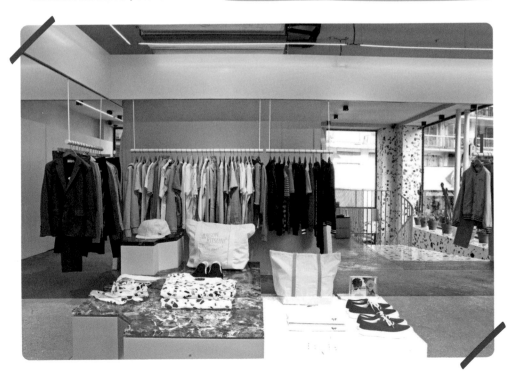

Hilditch & Key

Classic British style at its best. The company has been making shirts since 1899, so they certainly know what they're doing.

How to sound like a regular?

"On their website there's a guide showing you how to iron shirts perfectly. My wife got me to read it."

THE MUST-HAVES

The shirt, a timeless miracle, tailored in beautifully finished fabrics. Some people swear by Hilditch & Key for their pajamas alone. But if you have a pair, keep them well away from the women in your life, as some are capable of stealing them to use as daywear.

ADDRESS

252, rue de Rivoli, Paris 1er
73 Jermyn Street, London
Locations worldwide

ONLINE STORE

hilditchandkey.co.uk
International
delivery available

French Trotters

THE STYLE

Like all our favorite brands, the French Trotters' wardrobe, designed by Carole and Clarent Dehlouz, comprises simple, modern, timeless pieces. I love their slogan T-shirts (for example, "Super normal").

THE MUST-HAVE

The "Less is more" T-shirt.

ADDRESS

128, rue Vieille-du-Temple, Paris 3e

ONLINE STORE

frenchtrotters.fr
International
delivery available

How to sound like a regular?

"If you want to catch a glimpse of the designers, go to Yam'Tcha tea house (4, rue Sauval, Paris 1er)—it's their usual lunchtime hangout."

L'Exception

This is the concept store for French menswear designers (and womenswear, too). Brands include De Bonne Facture, Éditions M.R., and Montlimart—here you'll find all the cutting-edge names in independent French design (more than five hundred designers in total). And lots of exclusive pieces.

ADDRESS

La Canopée du Forum des Halles, 24, rue Berger, Paris 1er

THE MUST-HAVES

The classic overcoat by Éditions M.R. and a Breton sweater by De Bonne Facture.

ONLINE STORE

lexception.com
International delivery available

How to sound like a regular?

"I remember when L'Exception was just a website."

A.P.C.

Paris pure and simple. Everything
is uncluttered and minimalist.
At most you might find
a tiny slogan on a T-shirt
("Oh l'amour!" for example).
But the quirkiness ends there.

*How to sound like
a regular?*

"The brand's designer,
Jean Touitou, is too-too wonderful!"

THE MUST-HAVES

All the jeans. And the
legendary sweatshirt!

ADDRESS

35, rue Madame, Paris 6ᵉ
Locations worldwide

ONLINE STORE

usonline.apc.fr in the US or apc.fr/wwuk
International delivery available

Acne Studios

If you're ever asked what ACNE stands for, you can say it's an acronym for "Ambition to Create Novel Expressions," and that always impresses. ACNE's denims take their place among the best jeans in the world. The whole range is minimalist, and the collections seem almost unisex. Having said that, I don't imagine a bright pink ACNE knitted sweater is for everyone, but I've been wearing one for a year! And none of my stepsons has tried to steal it—yet.

How to sound like a regular?

"My ACNE sweater? I stole it from my wife!"

ADDRESS

124, galerie de Valois, Paris 1er
Locations worldwide

THE MUST-HAVE

Any of their knitted sweaters are must-haves.

ONLINE STORE

acnestudios.com
International delivery available

La Garçonnière

THE STYLE

This is a comprehensive men's lifestyle store (there's even an in-store barbershop) whose range of fashions is chosen for its wearability.

THE MUST-HAVES

Armogan watches and Triwa bracelets.

ADDRESS

40, rue des Petits-Carreaux, Paris 2ᵉ

How to sound like a regular?

"I found the best recipe for fish ceviche on La Garçonnière's website."

ONLINE STORE

la-garconniere.fr
International delivery available

Éclectic

All the jackets have a distinct personality through their innovative fabrics alone. My absolute favorite is the high-tech tux. The range of luggage makes you want to head for the airport straight away!

THE STYLE

Designer Franck Malègue has a real talent for bringing menswear up to date, while retaining a minimalist style. His clothes are made using traditional tailoring but they're cut from futuristic fabrics. It's a new look that has already become classic.

How to sound like a regular?

"It's crazy the way this brand is taking off. They've just opened their first store in New York, and there's a new outlet on rue Marbeuf in Paris (8e)."

ADDRESS

8, rue Charlot, Paris 3e
27 Greene Street, NYC

ONLINE STORE

e-eclectic.com
International delivery available

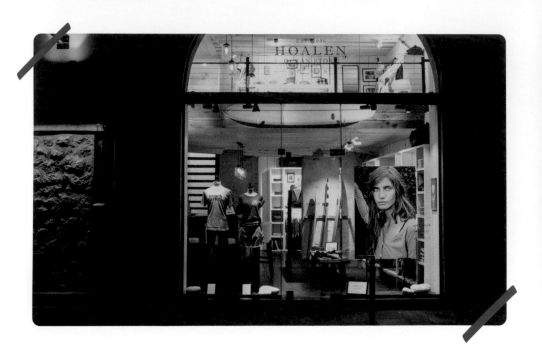

THE STYLE

Originally from Finistère on France's northwest coast, Hoalen's collections are inspired by the world of sports and the sea. Everyone seems to admire the style of California surfers, but I'm a fan of Brittany surfers. Arthur de Kersauson (my stepson) is one of Hoalen's style ambassadors, which explains my family ties to this brand.

THE MUST-HAVES

Whether or not they'll stock it every season, the "French surfers" T-shirt is a hit. Otherwise, all the Breton-style sweaters and sweatshirts are great.

ADDRESS

17, rue des Quatre-Vents, Paris 6ᵉ

ONLINE STORE

hoalen.com
International delivery available

How to sound like a regular?

"Hoalen means 'salt' in the Breton dialect. But it's not the salt you put on your food; it refers to sea salt and those who take to the seas for sport. But even if you get seasick you can still wear Hoalen."

Drapeau Noir

Ultra-simple. Basic, timeless pieces that combine easily with every kind of look. But a contemporary feel is never very far away.

THE MUST-HAVES

The Worker jacket is beautifully cut. But everything's definitely worth trying on, as this brand makes basics with a stylish twist.

How to sound like a regular?

"Drapeau Noir's designer, Nicolas Barbier, quit his job as an attorney to start this brand. Perhaps he wanted to raise the bar."

ADDRESS

75, rue Charlot, Paris 3ᵉ

ONLINE STORE

drapeau-noir.fr
International delivery available

Zadig & Voltaire

THE STYLE

Every fan of rock'n'roll style knows this brand, but it's always worth a reminder. Leather jackets, T-shirt with slogans such as "Kiss" or "Lover" or customized cashmere—there are always great pieces to create a virile look.

THE MUST-HAVES

The Henley T-shirt, of course, but also the jackets and the knitwear.

ADDRESS

2, rue Cambon, Paris 1ᵉʳ
Locations worldwide

How to sound like a regular?

"Did you know that Cécilia, the brand's artistic director and wife of the owner Thierry Gillier, has a twin sister who's just as pretty as she is?"

ONLINE STORE

zadig-et-voltaire.com
International delivery available

Bleu de Paname

THE STYLE

French-inspired workwear for the urban man.

How to sound like a regular?

"When they launched the brand in 2009, the two designers, Christophe Lépine and Thomas Giorgetti, wanted to keep it a secret. They failed!"

THE MUST-HAVE

The cotton twill counter jacket.

ADDRESS

68, rue Saint-Honoré, Paris 1er

ONLINE STORE

bleudepaname.com
International delivery available

Lacoste

THE STYLE

Luxury sportswear. With its crocodile-motif polo shirt, which could be listed as a historic monument of fashion, Lacoste needs no introduction.

THE MUST-HAVES

The polo shirt, of course, but their zipped bomber jackets are also a great buy.

ADDRESS

55, rue de Sèvres, Paris 6ᵉ
Locations worldwide

How to sound like a regular?

"'Life is a beautiful sport.'
It's Lacoste's slogan, but Novak
Djokovic could have said it."

ONLINE STORE

lacoste.com
International delivery available

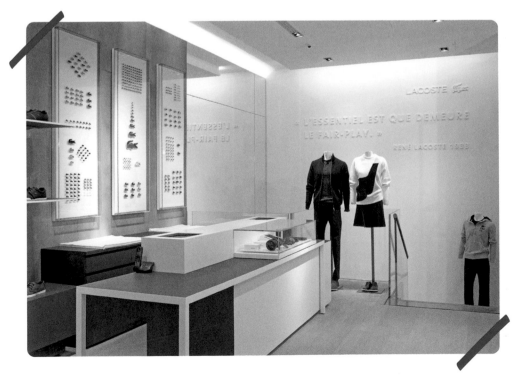

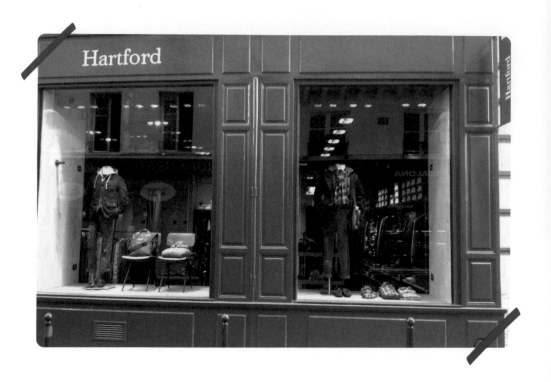

Hartford

American style given a French makeover, with great clothes for men, women, and children. Apart from a few print pieces that bring individuality to each season, the brand offers an attractive, simple look.

THE MUST-HAVES

The slim-fit shirts and mid-length swim shorts.

How to sound like a regular?

"It has a French feel, but the brand was actually created in the States in 1979, and even Bruce Springsteen wears Hartford."

ADDRESS

23, rue des Canettes, Paris 6ᵉ
Locations worldwide

ONLINE STORE

en.hartford.fr
International delivery available

Mad Lords

The reference when it comes to men's jewelry. It's tucked away in a courtyard, so if you didn't know about it you'd never stumble across it. You'll find pieces by designers such as Henson, Tobias Wistisen, or Mad Precious in a rock'n'roll atmosphere—it's manly and attractive.

ADDRESS

316, rue Saint-Honoré, Paris 1^{er}

ONLINE STORE

madlords.com
International
delivery available

THE MUST-HAVES

All of the bracelets
by M. Cohen.

How to sound like a regular?

"What's Serge wearing these days?" (Serge is the store's co-owner and he has great style.)

Charvet

THE STYLE

The oldest shirtmaker in the world boasts an inevitably classic style. Charles de Gaulle was a fan, and all the presidents of France's Fifth Republic have followed suit, from Georges Pompidou to Nicolas Sarkozy. Shirts (ready-to-wear and bespoke), made-to-measure suits, pajamas, and bathrobes, plus ties and bow ties—it's all one hundred percent tastefully made in France. If you're opting for bespoke, give yourself some time, as you can have five hundred different choices to make (fabric type, weight, etc.) just for a white shirt!

THE MUST-HAVES

The shirt, the Rolls-Royce of its kind. And all the ties.

How to sound like a regular?

"The father of the brand's founder was Napoleon's official dresser."

ADDRESS

28, place Vendôme, Paris 1er
Locations worldwide

ONLINE

charvet.com

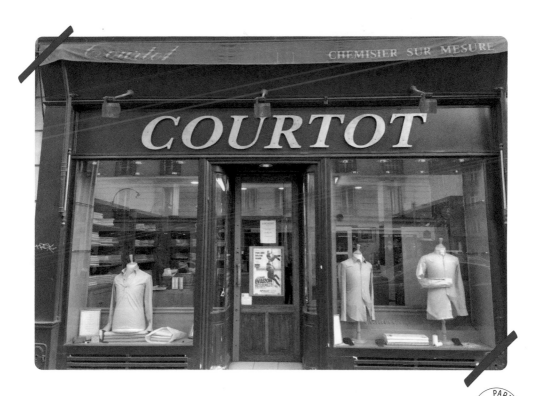

Maison Courtot

THE STYLE

These bespoke shirts may have less history than Charvet (Courtot was founded in 1962) but they're just as classic and made from high-quality fabrics. Shirts, pajamas, and boxers—they're all made in Paris and in the Courtot workshops in Houdan, west of Paris.

ONLINE

maison-courtot.com

How to sound like a regular?

"They'll keep your measurements for life—extremely useful!"

THE MUST-HAVES

The shirt, of course, but their boxer shorts are also a good bet.

Basic but chic.

39, rue des Francs-Bourgeois, Paris 4ᵉ
Locations worldwide

I'm tempted to say "all the pieces in my collection," but with fairness I can say that everything by Uniqlo has must-have potential.

uniqlo.com
International delivery available

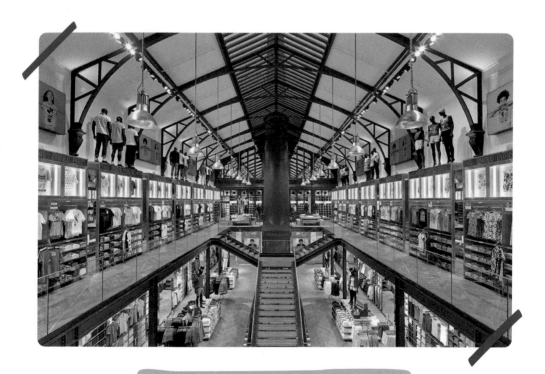

How to sound like a regular?

"Originally, Uniqlo clothes were unisex. And even today, lots of girls buy their cashmere knits in the men's department."

JLC Opticien

THE STYLE

The place to go for top-of-the-range glasses.
With high-powered design and flawless quality,
the brands selected by JLC have a proven track record.

THE MUST-HAVE FRAMES

JLC frames—and those of all the brands in this multi-label store
(including Oliver Peoples, Barton Perreira, Céline, etc.)—are must-haves.

How to sound like a regular?

"JLC's founder, Jean-Luc Chekroun, owns more
than four hundred pairs of glasses. He's a real
professional with a passion for his work!"

ADDRESS

19, rue de Bretagne, Paris 3ᵉ
68, rue du Bac, Paris 7ᵉ
18, rue Marbeuf, Paris 8ᵉ

PARIS EXCLUSIVE

ONLINE

jlcopticien.com

Jonathan Optic

THE STYLE

I love the idea that the boss, Jonathan,
aspires to bring us glasses that help us
look our best. This is no supermarket; here
customer service is the focus, full of advice
and information. For some purchases
I need the help of a professional,
and glasses are one example.

THE MUST-HAVE FRAMES

Whether Mykita, Moncler, Tom Ford,
or Cutler and Gross, you're bound
to find your must-have frames.

PARIS EXCLUSIVE

ADDRESS

17, rue des Rosiers, Paris 4ᵉ
19, rue Vignon, Paris 8ᵉ

How to sound like a regular?

"Jonathan also owns another store in Paris, L'Antiquaire
de l'Optique, where he sells unique and vintage models."

ONLINE

jonathanoptic.com

Gili's

THE STYLE

Always playful. Inspired by azulejos, the famous Portuguese ceramic tiles, Aymeric and Clarisse, the brand's founding couple, create highly colorful collections. For the moment Gili's caters for men and children only. Women will have to wait for their collection.

ADDRESS

7, rue du Cherche-Midi, Paris 6ᵉ

ONLINE STORE

gilis.com
International delivery available

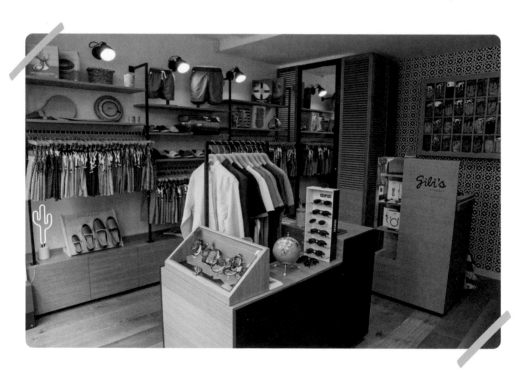

THE MUST-HAVES

The brand is expanding its range at lightning speed. I already love their shirts and T-shirts.

How to sound like a regular?

"If you're in Paris and need emergency swimwear, Gili's offers same-day delivery within the city."

Maison Corthay

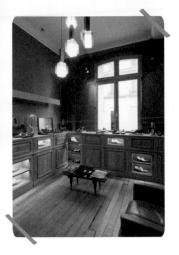

In the world of shoes, Corthay is haute couture. There's a bespoke department which has all the skills of the boot maker's savoir-faire at its fingertips—and a ready-to-wear department whose creations are just as well made and very colorful. At first glance they look totally classic, but these shoes always retain an original touch that is stylish and furiously modern. Corthay's small leather goods—wallets, cardholders, and coin pouches—provide the perfect gift ideas.

THE MUST-HAVE

Any pair, as long as it has the original patina (Corthay's gradient pigment is highly distinctive) or fluorescent lining—the company's signature style.

How to sound like a regular?

"In 2009, the company's founder, Pierre Corthay, was awarded the distinction of Maître d'Art by the French Minister of Culture. How many other boot makers do you know with the award?"

ADDRESS

1, rue Volnay, Paris 2ᵉ

ONLINE STORE

corthay.com
International
delivery available

SHOE CARE

✗ Consider investing in quality shoes—your return on investment on well-made and well-maintained shoes will be far greater than that on a string of cheap shoes that fall apart or make your dogs bark. Proper shoe maintenance can add years to their life, and your feet will thank you.

✗ Find a good shoe repair service and protect the heels and soles of your new shoes. Keep them looking spiffy with regular cleaning and waterproofing; maintain the insoles and store them properly with shoe trees. Be sure to color, polish, and refinish as needed and, when they show signs of wear, have them reheeled and resoled. You'll be walking on sunshine for years to come.
In Paris, we recommend:

Minuit Moins Sept (10, passage Vérot-Dodat, Paris 1ᵉʳ; minuitmoins7.com)
Take expensive shoes to the official repairer of Louboutin's famous red soles; this traditional cobbler's shop even sells its own brand of polish.

Attal (122, rue d'Assas, Paris 6ᵉ)
This local boot maker established its reputation with a range of bespoke leather sandals. It gets mobbed with girls who don't have time to go to Saint-Tropez for sandals, and there's a bespoke service for men.

L'Atelier d'Antoine (75, rue de Miromesnil, Paris 8ᵉ; latelier-dantoine.com)
Always on the list of Paris's best cobblers, Antoine celebrated forty years in the business in 2017. A specialist in complete, hand-stitched remakes, he can repair your shoes or change their color, create a patina or a *glaçage* (the traditional, deep-shine polish), and alter or change heels. He's a real magician!

GOING VIRILE
online

For menswear blogs, online stores,
fashion influencers, style tips,
or sartorial shopping 24/7,
the Internet is the best way
to keep up-to-date from
the comfort of your sofa.

These guys are super-stylish
and great sources of inspiration.

@thesartorialist

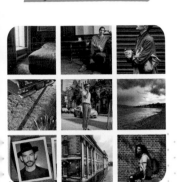

The pioneer in this field,
Scott Schuman tracks down
the best looks on the street,
and his photos are great.

@iamgalla

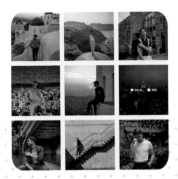

Adam Gallagher is the male muse
of effortless elegance, stylishly
showcasing his own looks.
He's the reason why I've almost
changed my mind about the tank
top: maybe it can be sexy....

@ringards

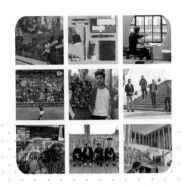

Four French guys with panache
and a sense of humor.
More and more they're working
in collaboration with brands,
but I find that a source
of inspiration as well.

@menwithclass

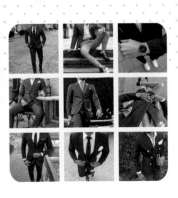

This Instagram account
is followed by millions posting
stylish tips on how
to carry off a suit.

@davidgandy_official

Ambassador for Giorgio Armani's
Light Blue men's fragrance,
this English supermodel
also makes videos. His USP
is an elegance that's very
British—and sexy.

@garconjon

Alongside his travel photography,
which is always very inspiring,
photographer Jonathan Daniel
Pryce tracks down the best
in men's style.

MRPORTER.COM

The most stylish online boutique

Brother of net-a-porter.com, mrporter.com is the most stylish destination in cyberspace. You'll find all the must-wear brands, even those you don't yet know that will quickly become essentials. The website often launches exclusive collections in collaboration with designers. And you can also watch videos, such as a masterclass on how to box—that can always come in handy.

International delivery available

ASOS.COM

For the insane selection

Brimming with thousands of items, asos.com is the perfect site when you absolutely must find something to wear. Tens of thousands of products are available at the click of a mouse, from labels of all kinds (with the accent on affordable sportswear lines, such as Levi's, Converse, and Carhartt) and the ASOS brand itself (very affordable). It's always a good place to get up to speed on the latest trends.

International delivery available

GRADUATESTORE.FR Style from Wine Country

Occasionally, Parisians look outside the capital for their style ideas. This site hails from the lovely town of Bordeaux, in the wine country of southwest France, where the first Graduate Store boutique opened in 2010, stocking a mixture of international designers (French, American, Scandinavian, Asian) and all the young labels in the news, such as OAMC. The epitome of style is being able to say, "It's from Bordeaux," when you're complimented on your outfit!

International delivery available

Improve your *français* and your style by browsing these exclusively French blogs:

MERCIALFRED.COM

THE GUIDE TO EVERYTHING NEW IN PARIS

Written like a men's magazine, this newsletter-cum-website offers ideas on which sites to go for when wasting time at work, and encourages the wearing of shorts to the office. Revolutionary stuff. Oh, and there's also practical information such as new restaurants to try out.

COMMEUN CAMION.COM

YOUR STYLE COACH

The first French blog to discuss men's fashion (in 2004) is packed with men's style ideas— what a great idea.

GENTLEMAN MODERNE.COM

THE MEN'S LIFESTYLE GUIDE

Blogs are not always just about fashion: find out how best to go about hair removal, what's the latest must-see movie, which is the best camera, or what car to buy—nothing is forgotten on this always up-to-the-minute men's lifestyle website.

SOS!
Gift emergency

Giving gifts is always a challenge. How can you be sure you're not making a mistake? What should you give to whom? With these very Parisian ideas, you'll never turn up empty-handed.

FOR A
BON VIVANT

A "Pit Bull" cigar. **Art Tabac** is the <u>best cigar store</u> in Paris, according to aficionados (2, place de Catalogne, Paris 14ᵉ).

A bottle of French wine. I rely on recommendations from the owner of the **Cave des Grands Vins** (144, boulevard du Montparnasse, Paris 14ᵉ; cave-des-grands-vins.com; international delivery available).

A **winemaking** or cooking course.

A **cookbook**.
For experienced cooks who want to perfect their roasted duck: *The Complete Bocuse* is the bible of classic French cuisine from chef of the century Paul Bocuse (Flammarion) or, for beginners, *Simple: The Easiest Cookbook in the World* by Jean-François Mallet (Black Dog & Levanthal).

Coldcuts from **Maison Vérot**, an *artisan charcutier* that has been going since 1930 (3, rue Notre-Dame-des-Champs, Paris 6ᵉ; maisonverot.fr).

FOR A FRIEND'S
HOUSEWARMING

A photo of Cary Grant or another legendary movie star (Clint Eastwood, Gregory Peck, etc.). Check out the selection available from **soniceditions.com**; international delivery available.

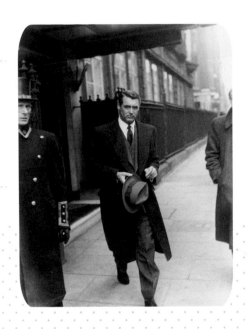

FOR A SUIT
DEVOTEE

A silk tie from **Charvet** (locations worldwide and at 28, place Vendôme, Paris 1er; charvet.com). They sell thousands of them, so you'll always find one you like.

Now, on the website **thecufflinksshop.com** (international delivery available), you can find the kind of cufflinks "don'ts" I warn against earlier in this book. But there are also some very plain ones, such as these steel nautical knots, or unpretentious solid silver cylinders.

FOR JEWELRY
JUNKIES

Super-sleek pieces by **Charlotte Chesnais**, the queen of minimalism, available at charlottechesnais.com or at White Bird (38, rue du Mont-Thabor, Paris 1er; whitebirdjewellery.com; international delivery available).

Ethically sourced pieces by **JEM** (jewelery ethically minded), available at jem-paris.com or by appointment at the JEM showroom at 40, rue de Verneuil, Paris 7e; +33 (0)1 85 34 70 22.

Talismans by **Pascale Monvoisin**, the designer with soul. Available at pascalemonvoisin.com or at Hod (104, rue Vieille-du-Temple, Paris 3e; hod-boutique.com; international delivery available).

FOR LINGERIE
LOVERS

A box of brightly colored panties. We love the ones from **Germaine des Prés**, available at germainedespres.com (international delivery available) or at 4, rue de la Planche, Paris 7e.

FOR THE WOMAN WHO LOVED
MY BOOK *PARISIAN CHIC*

I know it sounds like self-promotion, but in **my boutique** (24, rue de Grenelle, Paris 7ᵉ or at inesdelafressange.com) the gold ballet pumps are a best seller. There are also lots of gorgeous things such as sunglasses, notebooks, and even brooms. Alternatively, there's the **Roger Vivier** boutique (rogervivier.com), where you can buy really chic shoes and bags (and I'm not just saying that because I'm the brand ambassador). Also, look out for my collections at **Uniqlo** (uniqlo.com. All stores deliver internationally.). If you're ever asked what I do for a living, you can say I've got at least three jobs—not including writing this book!

FOR THE BAG
ADDICT

The bucket bag by <u>Céline Lefébure</u>, available at celinelefebure.com (delivery in France only) or at the **Bon Marché** department store (24, rue de Sèvres, Paris 7ᵉ; 24sevres.com; international delivery available).

Personalized bags by <u>LaContrie</u>, available from lacontrie.com or at **Merci** (111, boulevard Beaumarchais, Paris 3ᵉ; mercimerci.com). Both deliver internationally.

The Art of Happiness by the <u>Dalai Lama</u> is a gift that can come to the rescue in all sorts of situations!

FOR A NEWBORN

A comforter or decorative item. We love the ideas from **Le Petit Souk** (lepetitsouk.fr).

A wooden toy is always a hit. Parisians love those from **Il Était une Fois** (1, rue Cassette, Paris 6e; iletaitunefois-paris.fr; international delivery available).

FOR A CHILD UNDER 5

FOR OLDER CHILDREN

For a child between ages 5 and 10: A fun science or nature game.

For a girl between ages 6 and 10: Something kitsch from **Claire's** (claires.com; international delivery available). You probably won't understand this concept, but these garish little novelties (lip balm, barrettes, earrings, etc.) will delight little girls. And what's more, they're inexpensive!

For all children and teenagers:
A book from your favorite local bookseller: even if you know nothing about children, the bookstore staff will be able to help you. For the best advice on children's books in French, I go to **Chantelivre** (13, rue de Sèvres, Paris 6e; chantelivre.com; international delivery available).

HEY,
good lookin'!

You might think that men don't need to think too much about personal care, since they don't wear make-up and their imperfections are part of their charm. However, a good haircut, a heady fragrance, a perfect shave, and even a soupçon of hair removal can amp up a guy's attractiveness. Here are the essentials of Parisian grooming and tips.

BEAUTY
FOR THE BEAST

Any man can give himself a quick slap on the cheek to start the day, but really,
you can do better than that, even if you're already naturally good-looking.
Here are ten grooming tips from Parisians who are not afraid to pamper themselves.

1 - Nail it

Having your nails done doesn't mean applying nail polish. Taking care of your hands, which are continually exposed to the elements, will never be a waste of time. If the idea of going to a nail salon is a turnoff, you can get by at home by using a cuticle and/or hand cream that you leave on overnight. Having smooth, soft hands won't make you any less manly.

2 - Keep tweezers handy

Getting rid of those unattractive stray hairs is the best and easiest way to look neat. Eyebrows, ears, and nose—all rogue hairs must be banished. To avoid having to repeat the operation too often, consider laser hair removal—it works for ear and nose hair, too.

3 - Hydrate your skin with sunscreen

Unless you're a lifeguard, overly tanned skin is never chic. So, whenever you go out, apply a moisturizer with SPF, even in the city.

4 - Exfoliate

Perhaps you're one of those guys who think facial scrubs are for girls only. Think again! A weekly skin detox is one good habit that is actually quite virile (although, don't splash too much water around when you rinse off—the girls don't like that).

5 - Use lip balm

Don't wait until you're on the slopes to hydrate your kisser. Soft lips will always make an impression. . . .

6 - Switch your fragrance

Add an element of surprise. If you've been loyal to the same fragrance for years, take advantage of summer to make a change and take a break from your old scent. You'll be a new man— that's tantalizing.

7 - You are what you eat

It's a fact: men like wolfing down beef steaks and devouring fries. But to keep your skin from aging too quickly, add in a few greens, vegetables other than carbs, quinoa ("Huh? Quinoa?"—we can hear you from here), and a lot of fruit. It's also a great way to extend your life expectancy and preserve your ravishing good looks.

8 - Stand up straight

Quasimodo, the hunchback of Notre-Dame, been a sex symbol. So, when you go out, st straight. It not only gives you presence, b have fewer back problems too.

9 - Keep your dental app

Using whitening toothpaste is great forget to visit the dental hygienist teeth cleaning, it's all for nothin

10 - Smile

Some people forget this, bu way to look attractive with And if, on top of that, yo you'll never need Tinde

Delphine Courteille

Delphine is my official hairdresser, so of course she's a real professional. However, in her cozy salon tucked away in a tree-filled courtyard, she also welcomes lots of men, some of whom, it's said, are rather famous. Delphine can be found backstage at every fashion week, where her creativity is much in demand. She has been awarded the French National Order of Merit. A visit to her salon is surely the order of the day!

Studio 34
34, rue du Mont-Thabor, Paris 1er

Tel. +33 (0)1 47 03 35 35
delphinecourteille.com

David Lucas

David's success is based on his respect for his clients' wishes. Put like that makes it sound easy, but it's not a given with all hairdressers. With his talented team and a salon that's big enough that you're never bothered by the noise of your neighbor's hairdryer, David has created a place you can trust. Under the Monique brand, he has invented three keratin-based products that work miracles. And if you're in Paris you can choose from two salons: one on rue Danielle-Casanova and the recently opened salon in the revamped Hôtel de Crillon. This is the place for a luxury hair experience.

20, rue Danielle-Casanova, Paris 2e
Tel. +33 (0)1 47 03 92 04
davidlucas.fr

Hôtel de Crillon,
10, place de la Concorde, Paris 8e
Tel. +33 (0)1 44 71 15 45

Francis Kurkdjian

The creator of Le Mâle by Jean-Paul Gaultier, Lancôme Miracle Homme, and Kouros Cologne Sport by Yves Saint Laurent, Francis Kurkdjian has now opened his own bespoke fragrance workshop. His brilliant idea is unisex fragrances such as Aqua Universalis or Absolue Pour le Matin. And for a very memorable occasion you can create a special order or try his custom-made perfumes—at a slightly more expensive price, of course.

7, rue des Blancs-Manteaux, Paris 4e
Tel. +33 (0)1 42 71 76 76
franciskurkdjian.com
International delivery available

Frédéric Malle

Like a literary editor, Frédéric Malle is a perfume editor, who gives free rein to perfume makers to create the elixir of their dreams. He guides them during the creation of each fragrance, as he knows what will work (his nose has been immersed in perfume since birth, as he's the grandson of Serge Heftler-Louiche, the founder of Parfums Christian Dior). Among his successes are famous fragrances such as Carnal Flower by Dominique Ropion. Frédéric Malle worked with Alber Elbaz, formerly the fashion designer at Lanvin, to launch a perfume called Superstitious—it's sure to bring you luck.

37, rue de Grenelle, Paris 7e
Tel. +33 (0)1 42 22 76 40
fredericmalle.com
International delivery available

État Libre d'Orange

Antihéros, Fat Electrician, Remarkable People, and Tom of Finland are just some of the attention-grabbing names of fragrances created by Étienne de Swardt, a perfumer who maintains that his brand is a "declaration of independence". For a clean scent, choose Cologne, a wonderfully pure elixir.

69, rue des Archives, Paris 3ᵉ
Tel. +33 (0)1 42 78 30 09
etatlibredorange.com
International delivery available

By Kilian

Creating a luxury perfume brand from a standing start isn't easy, but Kilian Hennessy was more than up to the challenge. Admittedly, he did have something of a nose for business, as he's the scion of a long line of cognac makers. But he's ploughed his own furrow in creating these ultra-luxurious and intoxicating fragrances. With names like Apple Brandy, Single Malt, Back to Black, or Aphrodisiac, you can tell in advance that they'll be unforgettable.

20, rue Cambon, Paris 1ᵉʳ
Tel. +33 (0)1 40 39 94 14
bykilian.com
International delivery available

Comptoir de l'Homme

There's nothing worse than a good-looking man with a hairy nose! Make sure you're always a smoothie when in Paris by making an appointment at Comptoir de l'Homme, where it's never a bad idea to ask for a back wax or the "ears, nose, and brows" treatment. Take the opportunity to have your beard trimmed (if you have one) and get a massage, if life is stressing you out.

5–7, rue de Tournon, Paris 6ᵉ
Tel. +33 (0)1 46 34 04 18
comptoirdelhomme.com
International delivery available

SPA

Spa by Clarins

There's no lack of spas in Paris, so make the most of the choice! However, there is one with something of a plus: the Spa by Clarins at the Molitor baths allows you to use the swimming pool if you book the L'Escale Molitor treatment. Why not try the diving class, which takes place on the first Wednesday of every month? Otherwise, you have to be a member of Club Molitor to use this beautiful pool.

8, avenue de la Porte-Molitor, Paris 16ᵉ
Tel. +33 (0)1 56 07 08 50
mltr.fr/en

The Barber by La Barbière de Paris in the Hôtel de Crillon

Ever since it opened, the Hôtel de Crillon has been "the place to be," particularly for men who love organizing their business lunches here. To kill two birds with one stone, why not arrive a little early and get a perfect, old-school shave? Then afterward, you can kill a third bird by dropping in to the Shoe Care Salon by Devoirdecourt and giving your shoes their own beauty treatment.

10, place de la Concorde, Paris 8e
Tel. +33 (0)1 44 71 15 45
rosewoodhotels.com

Don't tell a soul, but... If a man is wearing Chanel's Cuir de Russie, he immediately becomes more desirable. Otherwise, for instant sexiness, go and chop or collect firewood and light a fire—this will make you smell really good. (Of course, finding the fireplace may be the biggest challenge of all.)

RESTAURANTS FOR
man-sized appetites

Even if we know some men who enjoy a salad, many are still fairly carnivorous. Here are some meaty addresses to sink your teeth into when you're in Paris and looking for a great meal.

MAISON BURGER

WHY EAT HERE? If you're looking for a relaxed atmosphere and burgers made with good-quality ingredients. But if you're eating with friends (a macrobiotic girlfriend, for example) who prefer something less substantial, they also do great quinoa salads. There are three branches in Paris (in the 6ᵉ, 10ᵉ, and 8ᵉ arrondissements). I like to order online and have the food delivered.

6, rue Grégoire-de-Tours, Paris 6ᵉ
Tel. +33 (0)1 43 54 40 13

20, rue du Faubourg-Saint-Martin, Paris 10ᵉ
Tel. +33 (0)1 42 85 22 08

20, rue de Ponthieu, Paris 8ᵉ
Tel. +33 (0)1 42 89 92 34

maisonburger.com

THE THING TO SAY

"I'm not that hungry,
so I'll take the cheese fries
with mini burgers."

PG'S

WHY EAT HERE? To impress any friend who thinks they know the best burger joints in town. The meat used in these burgers is exceptional (5 oz./140 g per burger). New, generously portioned dishes are served each week. The service is extremely friendly, and there are also craft beers on the menu.

15, rue d'Assas, Paris 6ᵉ
Tel. +33 (0)9 70 38 05 27
pgsbar.fr

THE THING TO SAY

"Wanna try *Ma petite luxury*?
It comes with foie gras
and cranberry sauce."

LE SEVERO

WHY EAT HERE? This is the place for carnivores who "know their onions." Owner William Bernet is a former butcher, so the quality of the meat is outstanding. Whether steak tartare, sirloin, or prime rib, all BBQ lovers adore this authentic little bistro.

THE THING TO SAY

"I'm going to order the prime rib for two people—and then eat the whole thing myself."

8, rue des Plantes, Paris 14e
Tel. +33 (0)1 45 40 40 91
lesevero.fr

LE RELAIS DE L'ENTRECÔTE

THE THING TO SAY

"Did you see the line outside the entrance? You'd think it's a new iPhone launch at the Apple store!"

WHY EAT HERE? If you just want *steak-frites* and prefer not to spend hours looking for a good eatery, Le Relais is the place to go—because that's all they serve! Start with a green salad, then move on to a double-size steak served with a sauce whose recipe is top secret.

15, rue Marbeuf, Paris 8e
Tel. +33 (0)1 49 52 07 17
relaisentrecote.fr

20, rue Saint-Benoît, Paris 6e
Tel. +33 (0)1 45 49 16 00

CLOVER GRILL

WHY EAT HERE?

Jean-François Piège's restaurant is all about food cooked over a charcoal grill or *rôtisserie*. Together with his wife Élodie, Jean-François has created a welcoming, convivial venue following in the footsteps of their first restaurant, Clover (5, rue Perronet, Paris 7ᵉ; +33 (0)1 75 50 00 05). Whether barbecued prime rib or grilled blue lobster, the flavors are incredible.

THE THING TO SAY

"Their puffed pizza is insane! The recipe is available on the website jeanfrancoispiege.com, but hey, we can't all cook like Jean-François Piège. I did test the recipe for Philip's cookie, though, and it was a winner."

6, rue Bailleul, Paris 1ᵉʳ
Tel. +33 (0)1 40 41 59 59
clover-grill.com

LE DRUGSTORE

WHY EAT HERE? Interiors are by English designer Tom Dixon (brass, marble, and leather banquettes). And chef Éric Frechon has created the menu. There's everything here, from wagyu beef to sea bream, or even light bites (such as madeleines with Parmesan or Swiss Gruyère cheese, and prawn fritters). And if you need somewhere to take grandma for afternoon tea, from 3 to 6 p.m. they serve a fantastic one. I'm going to create my Drugstore crew and hang out in this restaurant all day.

133, avenue des Champs-Élysées, Paris 8ᵉ
Tel. +33 (0)1 44 43 75 07
restaurantledrugstore.com

THE THING TO SAY

"Sometimes I drop in for breakfast at 8 a.m., and then come back again at midnight for dinner."

LE PETIT VARENNE

WHY EAT HERE? If you like La Laiterie Sainte-Clotilde (p. 216), you'll also fall for this little bistro run by the same owners. With its midnight-blue velvet banquettes and small tables topped in pebbled quartz, the decor is refined while retaining a typical Parisian bistro feel. The cuisine is great (oh, the salad vinaigrette and tender meat!). The added bonus? From 3 to 8 p.m., Le Petit Varenne serves snacks (cheese or meat platters and pastries).

57, rue de Bellechasse, Paris 7e
Tel. +33 (0)1 42 73 60 72

THE THING TO SAY

"I'll have dessert, and then stick around for some of their mortadella."

LE GRAND RESTAURANT

WHY EAT HERE? To celebrate a birthday, for a business lunch, or to propose marriage. Jean-François Piège creates a highly sophisticated experience in this gourmet restaurant, where the names of the dishes themselves transport you to a world of refinement—for example, jumbo langoustines cooked in *beurre noisette*, seafood *jus* with nasturtium flowers, and a shredded lobster claw soufflé. Book well in advance, as it's always packed.

DON'T SAY
"What's the name of this restaurant?"

7, rue d'Aguesseau, Paris 8[e]
Tel. +33 (0)1 53 05 00 00
jeanfrancoispiege-legrandrestaurant.com

L'ARÔME

THE THING TO SAY
"The owner started his career as the maître d'hôtel at the Élysée Palace, the French president's official residence."

WHY EAT HERE? Awarded a Michelin star in 2009, this restaurant owned by Éric Martins, originally from the Basque country, is elegant and welcoming. The open kitchen is run by chef Thomas Bouillault, who trained at the George V and then at the Royal Monceau hotel. From the John Dory fillet with chanterelle mushrooms and licorice to the suckling pig roast with *herbes de la garrigue*, the flavors are expertly combined. Like Le Grand Restaurant, it is perfect for a special occasion. If you bring a girlfriend here for a break-up, at least you'll leave her with a good memory of an otherwise unpleasant event.

3, rue Saint-Philippe-du-Roule, Paris 8[e]
Tel. +33 (0)1 42 25 55 98
larome.fr

LE GABRIEL
AT L'HÔTEL LA RÉSERVE

WHY EAT HERE? This restaurant opened in 2016 and has already been awarded two Michelin stars! Chef Jérôme Banctel (formerly of Lucas Carton and L'Ambroisie) conjures up a contemporary kind of cuisine with a few exotic touches. Norwegian salmon, confit with miso, black radish, and organic avocado or Bresse hen with herbs, ricotta printed ravioli, and horseradish butter—the flavors are always outstanding.

42, avenue Gabriel, Paris 8ᵉ
Tel. +33 (0)1 58 36 60 50
lareserve-paris.com

THE THING TO SAY
"Is the pigeon with cocoa still on the menu?"

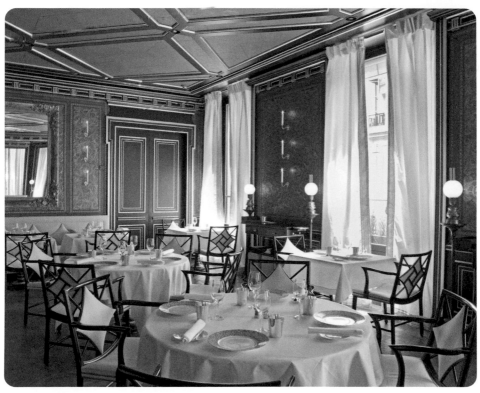

RESTAURANT DAVID TOUTAIN

WHY EAT HERE? There's no menu at this restaurant, so you're in for a treat when you choose from the various "surprise" menus. Still, giving carte blanche to chef David Toutain is an experience not to be missed. His second-in-command is Japanese, which explains some of the interesting flavor combinations.

THE THING TO SAY

"Even the tableware deserves a Michelin star."

29, rue Surcouf, Paris 7ᵉ
Tel. +33 (0)1 45 50 11 10
davidtoutain.com

LA SOCIÉTÉ

WHY EAT HERE? I featured this classic Costes restaurant in *Parisian Chic*. I love its cozy, fashion-friendly feel and its dishes, which are the essence of modern simplicity. The waiters are always welcoming, and the terrace overlooking the church of Saint-Germain-des-Prés makes a great backdrop for Instagram photos.

THE THING TO SAY

"I had lunch at Hôtel Costes, and since I didn't have time for the cheesecake, I thought I'd drop in here to avoid crossing the river again."

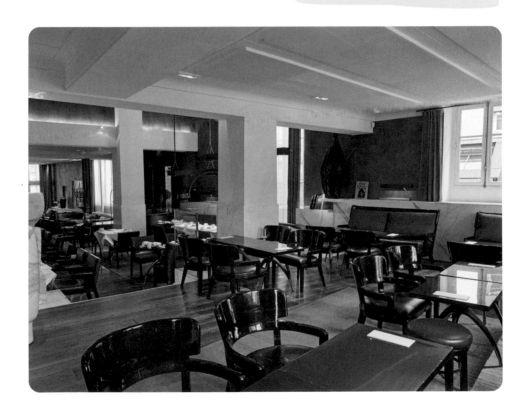

4, place Saint-Germain-des-Prés, Paris 6ᵉ
Tel. +33 (0)1 53 63 60 60
restaurantlasociete.com

LE PETIT LUTETIA

THE THING TO SAY

"I'll have the 'putain d'entrecôte' ['bloody' steak]."

WHY EAT HERE? For the atmosphere, which is always friendly. And for a real brasserie setting, which is a treat for anyone visiting Paris. Between the duck confit and the extra-large bowl of chocolate mousse, you'll never leave here hungry. A special shout-out goes to Christophe, the manager, who always guarantees a very warm welcome.

107, rue de Sèvres, Paris 6ᵉ
Tel. +33 (0)1 45 48 33 53

LA MAISON DE LA TRUFFE

19, place de la Madeleine, Paris 8ᵉ
Tel. +33 (0)1 42 65 53 22
maison-de-la-truffe.com

WHY EAT HERE? For the truffles, of course. But also for the elegant, minimalist surroundings. Here, it's all about this particular luxury ingredient, so make sure your guest loves truffles. Obviously, the food is excellent. If you prefer that other deluxe food—caviar—you can head over to Caviar Kaspia (17, place de la Madeleine, Paris 8ᵉ; +33 (0) 1 42 65 33 32; caviarkaspia.com), run by the same owner.

THE THING TO SAY

"I was debating about investing in the stock market, but I think I'll go into truffle growing instead. These little mushrooms are worth a fortune."

LE BON GEORGES

WHY EAT HERE? For its slate menu and its very Parisian atmosphere. Everything is made from seasonal ingredients, sourced from small French producers and independent fishermen. The wines are divided into two menus: "petites quilles [little bowling pins]" at affordable prices and "grandes quilles [big bowling pins]" with nothing but the top shelf names.

THE THING TO SAY

"All their suppliers are passionate about their work—just like Benoît, the manager."

45, rue Saint-Georges, Paris 9ᵉ
Tel. +33 (0)1 48 78 40 30
lebongeorges.com

CHEZ GEORGES

WHY EAT HERE? This authentic brasserie still maintains its old-time feel and has retained its soul, which *bon vivants* adore. It serves good French cuisine: good pâté, good fries, good green beans, good meat and good fish, good lentil salad, good raspberry tart, and good profiteroles: all of which is good for morale.

1, rue du Mail, Paris 2ᵉ
Tel. +33 (0)1 42 60 07 11

THE THING TO SAY

"This place has been around since 1964, so they know what they're doing."

LA LAITERIE SAINTE-CLOTILDE

THE THING TO SAY

"La Laiterie means the dairy, but don't panic—they serve excellent wines!"

WHY EAT HERE? For the vintage interiors (wow, Formica chairs!) and the constantly changing menu, based on fresh market produce. The soups are great. I tried sliced pork cooked in milk, and pineapple macerated in ginger and lime, both of which made me want to come back. The check is reasonable considering this is an upscale neighborhood.

64, rue de Bellechasse, Paris 7e
Tel. +33 (0)1 45 51 74 61

L'AMI JEAN

WHY EAT HERE? To see a neo-bistro that's not trying to be cool, but simply *is* naturally cool. Chef Stéphane Jégo has mastered the art of bistro cooking and manages to make unusual flavor combinations look easy. The appetizer of deconstructed Parmesan cream soup deserves a more prominent place on the menu. And don't leave without tasting Stéphane's famous rice pudding!

THE THING TO SAY

"Chef Stéphane Jégo isn't just a good chef, he also has a good heart: he took part in the Refugee Food Festival and invited a Syrian refugee, who's a chef, to cook in his restaurant."

27, rue Malar, Paris 7ᵉ
Tel. +33 (0)1 47 05 86 89

TOMY & CO

WHY EAT HERE? For perfectly prepared, full-flavored dishes. Tomy Gouset and his team are kings of bistro food, and since the restaurant opened in 2016 Tomy & Co has continued to attract a lot of interest. Whether lobster with chorizo or chicken with foie gras, sweetcorn, and broccoli, the choice is always inventive. And don't get me started on the white chocolate tart with wild strawberries, caramel, and strawberry-and-basil ice-cream....

THE THING TO SAY

"*Life is food*, as it says on the wall."

22, rue Surcouf, Paris 7ᵉ
Tel. +33 (0)1 45 51 46 93

MARIUS

WHY EAT HERE? For their fried squid with tartare sauce, but not just that—from oysters or langoustines to sea bream, cod, or turbot, all the fish here is good. And even if you come here to enjoy the bounties of the sea, don't leave without trying the apple tart, this restaurant's signature dish. In summer, the terrace is charming.

THE THING TO SAY

"Hi Marie-Claire, how's François?" (Some people mistakenly call the chef Marius, but his name's François Grandjean and his wife is Marie-Claire.)

82, boulevard Murat, Paris 16e
Tel. +33 (0)1 46 51 67 80
restaurantmarius.fr

LE PLOMB DU CANTAL

3, rue de la Gaîté, Paris 14e
Tel. +33 (0)1 43 35 16 92
leplombducantal.com

WHY EAT HERE? For Auvergne specialties and to eat *aligot* (mashed potatoes, melted fresh Tomme d'Auvergne cheese, and garlic) as they do in the Auvergne region. The Aveyron-style stuffed cabbage or the *truffade* (fried potatoes, fresh Tomme d'Auvergne cheese, and garlic) combined with the rustic interiors offers an affordable way of taking a trip to this pretty region of central France.

THE THING TO SAY

"We need to preserve local cuisine."

LES AVANT-COMPTOIRS

WHY EAT HERE? For a tapas snack on movie night. Whether it's lobster ravioli or oxtail *croque*, this is definitely food for heavyweights. The wine cellar is worth exploring too. The atmosphere is relaxed (expect a crowd at the counter, where all the action takes place). Chef Yves Camdeborde is always full of good ideas: after L'Avant-Comptoir de la Terre took off, he opened the neighboring L'Avant-Comptoir de la Mer in 2016.

THE THING TO SAY

"The Avant-Comptoir de la Mer won Best Restaurant-Bar at the 2016 Time Out Paris Bar Awards."

L'Avant-Comptoir de la Terre
3, carrefour de l'Odéon, Paris 6ᵉ

L'Avant-Comptoir de la Mer
3, carrefour de l'Odéon, Paris 6ᵉ
Tel. +33 (0)1 44 27 07 50
No reservations

CHEZ RENÉ

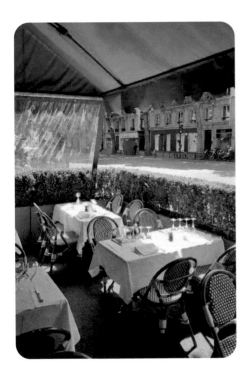

WHY EAT HERE? From grilled marrow bone with thyme flowers to frogs' legs and Lyon sausage, expect pure French cuisine here. Nothing has changed since the 1950s (white tablecloths and red leather banquettes) and the chocolate mousse tastes exactly like the one I used to eat when I was little. This restaurant provides comfort food at its very best.

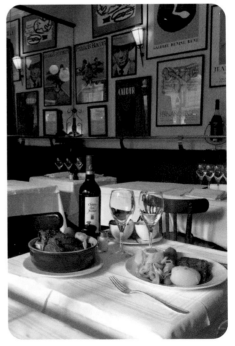

DON'T SAY
"Do you have any quinoa?"

- - - - - - - - - -

14, boulevard Saint-Germain, Paris 5ᵉ
Tel. +33 (0)1 43 54 30 23

L'ORÉE DU PARC

THE THING TO SAY

"I use this restaurant to test whether a girl is really cool. If she likes it, I can see a future with her, but if she doesn't, she's not much fun."

WHY EAT HERE? For its traditional feel, which is friendly and "come as you are." Everything is really good, and the ambiance is simple and very French. It's a bistro like many others in the capital, but not all of them have such a good reputation when it comes to food. Charcuterie and *aligot*, snails or *steak-frites*, it's as French as they come.

9, rue de l'Abbé-de-l'Épée, Paris 5e
Tel. +33 (0)1 43 54 41 99

LE GRIFFONNIER

WHY EAT HERE? Cold cuts, marrow bone, steak with béarnaise sauce, and stuffed cabbage—this is a guys' restaurant par excellence. All boys love this place—bankers, politicians, doctors, businessmen, or journalists—because it's a great hangout for both friends and foodies. Cédric, the owner, hails from Normandy. He's very welcoming and you'll want to come back just to see him again. A word of caution: in light of the amazing wine list, you shouldn't plan any important business meetings after lunch.

8, rue des Saussaies, Paris 8e
Tel. +33 (0)1 42 65 17 17

THE THING TO SAY

"On Thursday evenings I bring my wife—it's the only night the restaurant is open. At lunchtime, there are too many men!"

BISTROT MARLOE

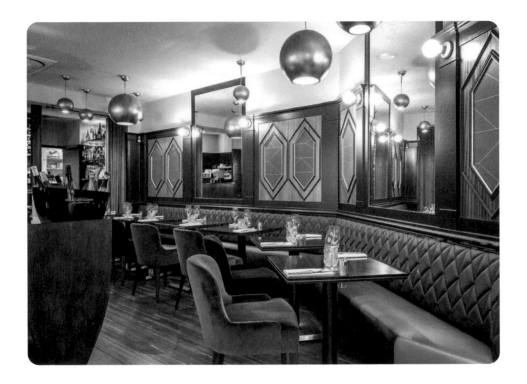

THE THING TO SAY

"I always go for their specials,
such as the dry-aged beef.
You only live once!"

WHY EAT HERE? Simply to try out the bistro
linked to the restaurant L'Arôme. It's a great
brasserie that has managed to stay up-to-date.
Grandpa Leroy's famous croque monsieur
is back on the menu, as is the pan-fried
squid in satay sauce.

12, rue du Commandant-Rivière, Paris 8ᵉ
Tel. +33 (0)1 53 76 44 44
marloe.fr

LE CRÔM-EXQUIS

WHY EAT HERE? For those small croquettes filled with melt-in the-mouth foie gras that you'll want to nosh by the bucketful. Businessmen love to lunch here because you can sit in small banquette booths that guarantee complete privacy. The cooking is always bold, thanks to young chef Pierre Meneau, the son of famous Michelin-starred chef Marc Meneau (awarded 19/20 in the Gault & Millau guide for his restaurant L'Espérance, which he ran for forty-three years). Currently, Pierre is happy to pursue a career on TV cooking shows, but his chicken supreme with apricots and verbena *jus* certainly deserves a few stars.

THE THING TO SAY
"The Exquis is exquisite!"

22, rue d'Astorg, Paris 8ᵉ
Tel. +33 (0)1 42 65 10 74
cromexquis.com

CIRCONSTANCES

WHY EAT HERE? It's always good, the atmosphere is welcoming without being too cozy, and it provides value for money. The menu changes all the time, as the cuisine uses seasonal produce. And to give you an idea of the restaurant's modern style, just one example of a starter that appeals equally to men and women is slow-cooked egg with mini chanterelle mushrooms and bacon.

THE THING TO SAY

"Can I order two starters as well as my main course?"

174, rue Montmartre, Paris 2e
Tel. +33 (0)1 42 36 17 05
circonstances.fr

FOR THE BEST
EGG MAYONNAISE

L'ÉVASION

WHY EAT HERE? For the deviled eggs, the restaurant's signature dish, which were voted top *œufs mayo* in 2012 by France's Egg Mayonnaise Protection Association. In any case, you won't leave this restaurant hungry: their *pâté en croûte*, pan-fried veal sweetbreads, steak tartare, and rum baba will keep your cholesterol topped up.

7, place Saint-Augustin, Paris 8e
Tel. +33 (0)1 45 22 66 20
restaurant-levasion.com

THE THING TO SAY

"I'll start my diet tomorrow."

IANNELLO

WHY EAT HERE? Because it's rare for restaurant owners—even Italian ones—to take the trouble to explain the difference between *burrata* and *stracciatella di burrata*. This is a genuine, traditional Italian restaurant, and one that uses high-quality products from southern Italy.

17, boulevard Exelmans, Paris 16e
Tel. +33 (0)1 46 47 80 08
iannello.fr

THE THING TO SAY

"I'll have the crab linguine."

CACIO E PEPPE

WHY EAT HERE? The restaurant is named after a pasta recipe that features cheese and pepper. And this sets the scene, because the decor is not what is most striking in this restaurant that's Italian through and through. The dishes are generous and the products and food of excellent quality—the manager's good humor does the rest.

16, rue Vulpian, Paris 13e
Tel. +33 (0)1 45 87 37 00

THE THING TO SAY

"They say *tout le Monde* eats lunch here, because the offices of *Le Monde* newspaper are right next door."

GENTLEMEN 1919

WHY EAT HERE? Fancy smoking a cigar, getting a haircut or a shave, having your shoes polished, all while enjoying a cocktail? This was Sébastien Paucod and Maxime Simonneau's brainchild. And it works perfectly. It's a place created by men for men, and you might wonder how guys have managed without it until now. If you fancy a snack, you can order a plate of cold cuts.

THE THING TO SAY

"Where are the girls?"

11, rue Jean-Mermoz, Paris 8ᵉ
Tel. +33 (0)1 42 89 42 59
gentlemen1919.com

AUX PRÉS

WHY EAT HERE? You don't ask why you should eat in one of Cyril's restaurants, you just do it. Now a TV star, this chef succeeds magnificently in surrounding himself with people who do the work for him. But as he has a very good team; everything runs like clockwork. My favorite dishes are the organic beef burger and the vanilla profiteroles.

THE THING TO SAY

"Is Cyril off filming
something right now?"

27, rue du Dragon, Paris 6ᵉ
Tel. +33 (0)1 45 48 29 68
restaurantauxpres.com

SLEEP LIKE
a Parisian

One of the joys of visiting Paris is discovering its hotels, whether small and intimate or spacious and luxurious. Parisians themselves also keep up to date with the latest in big city hospitality by making sure they know the best features of Paris's hotels—from restaurants and bars to pools and spas. Here's a list of our favorites.

Hôtel Ritz

I can always find a good reason to go to the Ritz. Since it reopened in 2016, I've even launched some of my brand's collections there. I've been coming here for so long, some of the staff think I'm part of the furniture. I love having lunch, but it's also great for afternoon tea, especially in the small garden, which is an oasis of calm in the heart of the capital. Obviously, the cost of a room is not the same as you'd find at a motel chain, but that's the cost of a luxury hotel, and includes the privilege of staying in a room overlooking one of the most beautiful squares in Paris.

THE THING TO SAY
"I adore the
Coco Chanel suite."

15, place Vendôme, Paris 1er
Tel. +33 (0)1 43 16 30 30
ritzparis.com

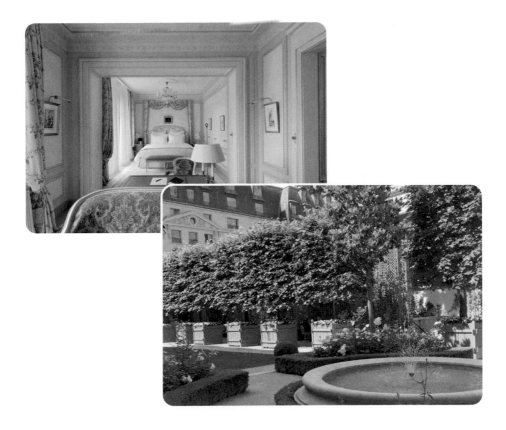

Hôtel de l'Abbaye Saint-Germain

It's considered a historic hotel, but it only opened in 1972. I was born long before then, but I certainly don't consider myself historic! Still, this hotel oozes charm, especially its small tree-lined courtyard when it's bathed in sunshine. One of the best value-for-money hotels in this neighborhood.

10, rue Cassette, Paris 6ᵉ
Tel. +33 (0)1 45 44 38 11
hotelabbayeparis.com

THE THING TO SAY
"It's so quiet, you'd think you were in the countryside."

THE SMALLEST FIVE-STAR HOTEL IN PARIS

L'Hôtel

If you're looking for a luxury hotel that isn't flashy, this is the place. Although this is where Oscar Wilde spent his last days, the pretty twenty-room hotel remains one of Paris's best-kept secrets, which contributes to its mysterious quality. The bonus is that the hotel has a swimming pool set under a vaulted stone ceiling, plus steam baths.

13, rue des Beaux-Arts, Paris 6ᵉ
Tel. +33 (0)1 44 91 99 00
l-hotel.com

THE THING TO SAY
"I love the name of this hotel. Although it can be confusing for the taxi driver, when you ask to be taken to 'The Hotel'."

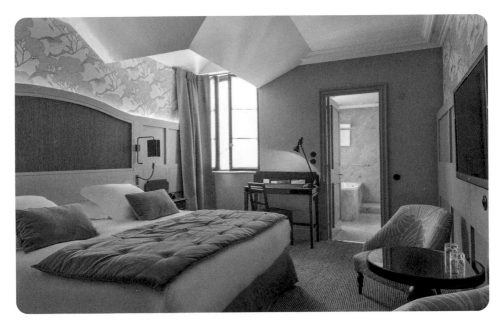

Hôtel d'Aubusson

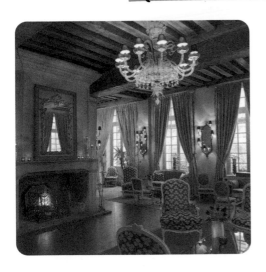

This could go in the category of "most romantic hotel in Paris" (the number of men who have proposed here must be considerable), but I prefer to emphasize the friendliness of the staff in this establishment. Of course, in hotels of this standard, they certainly *should* be friendly, but this is not always the case—which is why it's worth mentioning here!

33, rue Dauphine, Paris 6ᵉ
Tel. +33 (0)1 43 29 43 43
hoteldaubusson.com

THE THING TO SAY

"I mainly go because I love the jazz concerts." (The hotel has a bar with a great program of jazz events).

Hôtel Providence

This hotel belongs to the new breed of establishments that are both stylish and welcoming. Above all, it's totally Parisian. Just eighteen rooms and ten very different universes—from the classic simplicity of dark blue walls to highly decorative, floral wallpaper. All are furnished with vintage pieces.

90, rue René Boulanger, Paris 10ᵉ
Tel. +33 (0)1 46 34 34 04
hotelprovidenceparis.com

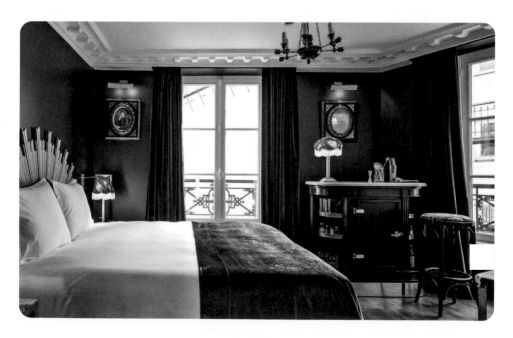

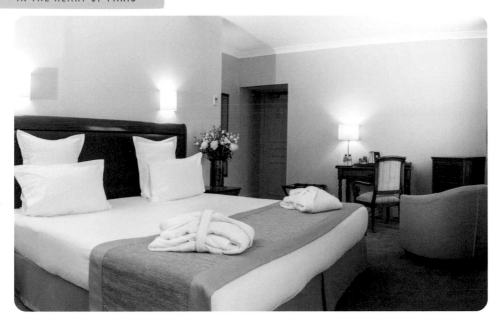

Saint James Albany

This four-star hotel is located on the rue de Rivoli, not far from the grand luxury hotels of the place Vendôme and the place de la Concorde. Don't expect a plush cocoon—it's simple and stylish, but the most charming features are the garden, where you can have lunch, and the pool. And what's more, the prices are not those of a luxury hotel.

202, rue de Rivoli, Paris 1ᵉʳ
Tel. +33 (0)1 44 58 43 21
saintjamesalbany.com

THE THING TO SAY
"Fancy a trip to Polynesia?"
(Polynesia is the name
of their spa treatment for two.)

233

Le Montana

In addition to its hotel business (just six suites all decorated differently), this location is also home to a restaurant, a bar, and a nightclub. And recently, it's also been possible to dine on the roof terrace with a superb view across Paris.

THE THING TO SAY

"I'm not tired, so I'm going to finish the evening off at the nightclub!"

28, rue Saint-Benoît, Paris 6ᵉ
Tel. +33 (0)1 53 63 79 20
hotel-lemontana.com

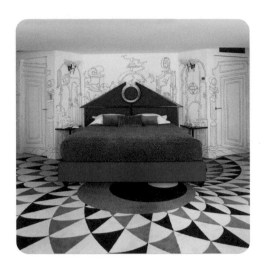

9 Hôtel Montparnasse

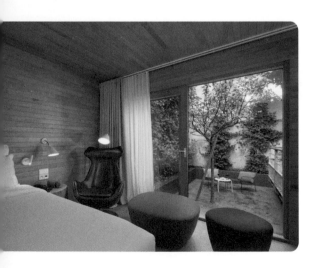

Friendly décor with a reception that's open twenty-four hours a day, plus a bar and garden. The prices are not always thrifty (it all depends on the season), but nevertheless it's excellent value for money, given its location very close to lots of transportation connections.

THE THING TO SAY

"The bedroom decorated in pale wood with a little terrace makes you feel like you're in the heart of the countryside."

76, rue Raymond-Losserand, Paris 14ᵉ
Tel. +33 (0)1 40 52 12 40
9-hotel-montparnasse-paris.fr

234

L'Hôtel National des Arts et Métiers

This most recent of the design hotels also boasts a "happy hour" and a good Italian restaurant. Materials are everything in this hotel of sixty-six rooms, designed by art director Raphaël Navot. I love the patio with its glass roof (which opens when it's hot), and the terrace on the top floor, which offers a 360-degree view of Paris. The hotel's Italian restaurant—the Ristorante National— is always packed, so it's best to call a few days in advance to book a table.

THE THING TO SAY

"The concrete walls in the bedrooms look like wood paneling. I love it! I'm going to see if I can create the same effect at home."

243, rue Saint-Martin, Paris 3e
Tel. +33 (0)1 80 97 22 80
hotelnational.paris

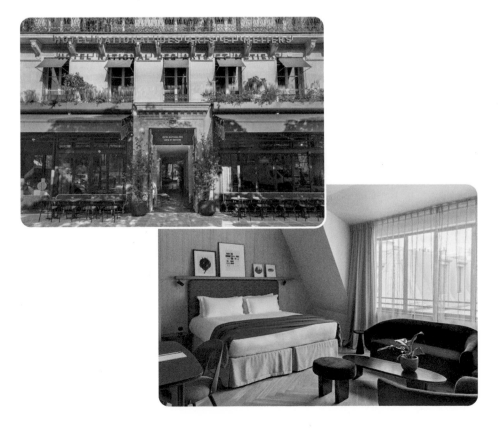

236

Thanks to

Adam, who did so much for fig leaves
(the only clothing you can eat).

Apollo, the first male model (even if he didn't
do much for fashion).

Sigmund Freud who, without knowing it,
started the fashion for (bearded) hipsters.

Gandhi for minimalism.

Gary Cooper for his entire career.

Stan and **Simon**, restaurant aficionados
who know what's good.

Aramis and **Sienna**, whose mom had to finish
this book during their vacation, and who were
just as inventive as Mary Poppins when it came
to looking after their little brother.

All the guys in this book, who prove that
a Parisian is much tastier than a simple
ham-and-butter sandwich.

Steve McQueen, without whom this book
could never have been made.

BACKSTAGE

NOTES